EXPRESSIVE
COLOR

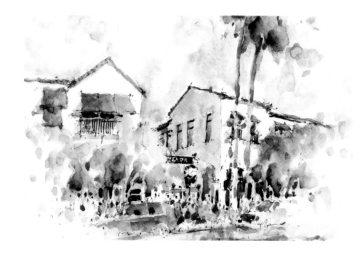

By Joseph Stoddard

Walter Foster Publishing, Inc.
23062 La Cadena Drive
Laguna Hills, CA 92653
www.walterfoster.com

Project Editor: Elizabeth T. Gilbert • Designer: Shelley Baugh • Copyeditor: Meghan O'Dell

CONTENTS

INTRODUCTION

This book will show you how to make your watercolors sing with bright, clear color. As you already know, many factors contribute to a successful painting. For many of us, color is the one element that stands out more than any other. We notice and respond to it either positively or negatively, but we all respond in some way.

Color is also the most exciting part of the painting process—at least for me. I love to see the explosion of new gamboge as it interacts with phthalo blue and creates an effect that is purely accidental, or the way opera mingles with cobalt blue to make a lavender that glows on the paper. Watercolor, in the way I work with it, is an art form similar to jazz. The music has structure, like the composition of a sketch, but within that structure are spaces for freeform expression, like John Coltrane's saxophone work in *A Love Supreme* . . . pure magic.

This book will help you organize your sketch work and explore composition and value, with the ultimate goal of showing you how to develop paintings that have a sense of order, a clear statement of intent, and plenty of room for bold expressions of exciting color.

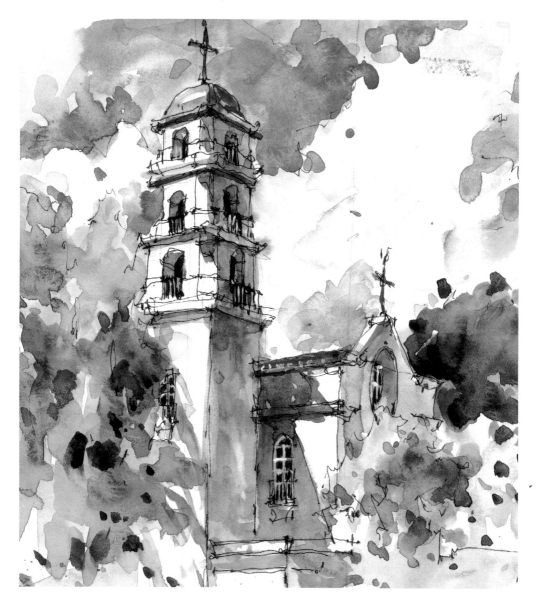

TOOLS & MATERIALS

If you're like most artists, you will do the majority of your painting in your studio. Some of you will have the luxury of a designated art area where you can set up your equipment and leave it there; others will have to make do with the kitchen table and share your studio with the rest of the family. For years I used my dining table before taking over my garage. Whatever your situation, you'll want to set up an area for yourself that is comfortable, well lit, and equipped with a good selection of art materials. On these pages, I'll explain all of the tools and materials I use.

Watercolor Paint

Artist vs. Student Grades

I always buy artist-grade paints over student-grade paints. Most manufacturers make both types. Artist-grade paint flows easier, goes on smoother, and lasts longer than the student grade. Student-grade paint uses synthetic substitutes for many of the pigments, and the colors aren't as lightfast as the higher grade. (*Lightfast* refers to the permanence of the colors when exposed to light over a long period of time; the more lightfast a color, the less likely it is to fade.) If you can afford to buy the higher-quality artist-grade paints, you will have greater satisfaction and quicker success.

Opaque vs. Transparent

Watercolors come in two types: opaque and transparent. Opaque watercolor is also known as "gouache" and is similar to the tempera paint you used in school. Gouache contains white pigment mixed with the color, which allows the paint to cover an area with clean opacity. (However, you *can* thin gouache and paint with it transparently if you desire.) Transparent watercolor is what watercolor artists traditionally use. The transparency of these paints allows either the white of the paper or a previously applied color to show through. It is this quality that gives watercolor paintings their luminous glow. (For more on transparent and opaque watercolors, see pages 16–17.)

Tubes vs. Pans

Watercolor paint comes in two main forms: tubes and pans. Tube paints are like little toothpaste tubes and contain paint in a soft, squeezable form. Pans are dried cakes of pigment that come in small plastic cups (or pans). To use pan watercolors, you must activate the pigment by applying water with a brush. If you are going to paint while traveling, pans are generally considered best because they are dry and transport easily (less mess!). Although I occasionally use paint sets that contain pans, I much prefer tube paints—even for my location/travel painting. (For travel, I squirt tube paints in my travel palette wells and let them dry for a day or so, just enough to harden up slightly. The paints reactivate easily with water.) It has been my experience that tube paint is fresher and the colors are brighter than pan paints. Tube paints are also easier (and more fun) to paint with. My painting style involves scooping big brush loads of paint onto the paper. This is much easier to do with creamy-right-out-of-the-tube paint.

Colors

The following is my current palette of colors. These are the paints I use for all the demonstrations in this book. My list does change occasionally, and yours should too as you experiment and grow as an artist. (In addition to the colors shown below, I use titanium white.)

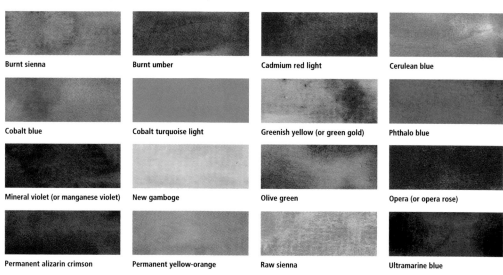

Burnt sienna	Burnt umber	Cadmium red light	Cerulean blue
Cobalt blue	Cobalt turquoise light	Greenish yellow (or green gold)	Phthalo blue
Mineral violet (or manganese violet)	New gamboge	Olive green	Opera (or opera rose)
Permanent alizarin crimson	Permanent yellow-orange	Raw sienna	Ultramarine blue

Mixing Palette

My studio palette is made of heavy plasti and has a lid that serves as a place to set container and brushes. The lid also helps paint fresh between painting sessions, with the help of a moist paper towel placed inside. Add fresh color to your palette every time—don't squirt in the whole tube and let it dry. Leave paint in the wells and add a little more each time you paint; this will ensure that you'll always have fresh, moist paint to work with. If or when some of the paint dries, clean it out and replace it. You don't want to ruin a $50 brush to scrape out a few cents' worth of pigment from a dried lump of paint.

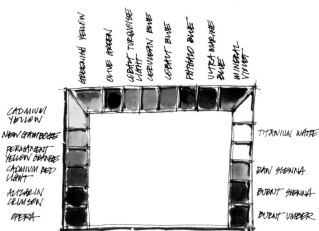

It's a good idea to organize your colors in spectrum order so you can easily remember their locations. If you're uncertain about where to start, try this: Paint a 1-inch x 1-inch swatch of each color on watercolor paper and cut them out. Place these color cards in the wells of your palette and shift them until you find a sequence that feels comfortable.

◀ **Setting Up Your Palette** This image shows the order of colors on my palette. I start at one end with my reds and work around the palette in color-wheel fashion: oranges, yellows, greens, blues, and purples. I have my earth tones at the opposite end. When I use white, I locate it between purple and the earth tones.

Paintbrushes

Shapes and Sizes

Brushes come in a wide variety of shapes and sizes. Watercolor artists primarily use two types: round and flat. Round brushes are best for general painting. Flat brushes are usually used for wide, generous washes across the paper, although some artists use flats exclusively. I prefer round brushes for most of my painting, but I also keep a sword liner and rigger on hand; these fine brushes produce thin lines and are perfect for adding details.

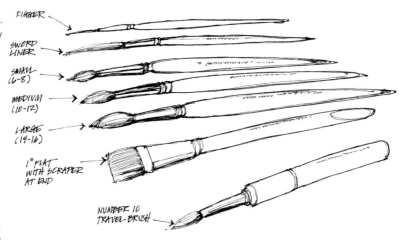

RIGGER

SWORD LINER

SMALL (6-8)

MEDIUM (10-12)

LARGE (14-16)

1" FLAT WITH SCRAPER AT END

NUMBER 10 TRAVEL BRUSH

Brushes come in many sizes. Flat brushes are generally sized by the width of their bristles (in inches), whereas round brushes are sized by a number (000 is the smallest and 24 is the largest). Brushes from different manufacturers may vary in size; for example, a number 10 from one company might be the same size as a number 12 from another. To keep things simple in the lessons of this book, I refer to brushes as either small, medium, or large. Small refers to a size between a number 6 and a number 8; medium refers to a size between a number 10 and a number 12; and large refers to a size between a number 14 and a number 16. Throughout the lessons, I suggest you use the largest brush you are comfortable with while painting a particular area. This will help you stay loose and avoid painting too much detail.

Brush Types

The majority of watercolorists use either natural brushes (made from animal furs such as sable and squirrel); synthetic fiber brushes; or a combination natural/synthetic fiber brush. Natural brushes are the most expensive, but they hold a lot of paint and are quite enjoyable to paint with. Synthetic brushes are the least expensive, but they can be difficult to control and don't hold as much paint. I have found the natural/synthetic combination brushes to be the best blend of affordability and performance. As with everything else, get the best brush you can afford, and you will be rewarded with excellent results.

Brush Care

Take good care of your brushes, and they will be with you for a long time. Here are the most important points to remember about brush care:

1. Always immerse your brushes in water before dipping them into paint.
2. Never leave brushes resting on the hairs or soaking in water.
3. Clean brushes thoroughly after each painting session with warm water.
4. Reshape your brushes after cleaning and rest them bristles-up in a jar to dry.

Masking Fluid

When painting night scenes, I use liquid frisket (also called "masking fluid") to block out light sources. This medium goes on like thick paint and dries to form a transparent resist on the paper. You can paint right over the masked areas. When your painting is completed, you can remove the mask with an eraser to expose the clean, white paper underneath. For more on using liquid frisket, see page 54.

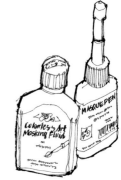

Watercolor Paper

Most watercolorists use paper made from 100 percent cotton. This paper is referred to as "rag paper" and is archival (which means that it's acid-free and it won't discolor with age). There are three basic paper finishes: hot press, which has a smooth finish; cold press, which has a slight texture and is the most common among painters; and rough, which is heavily textured. Watercolor paper comes in three basic weights (or thicknesses): 90 pound, which is the lightest and thinnest; 140 pound, which is a medium weight and is the most common; and 300 pound, which is the heaviest. I generally use 140-pound paper.

Unlike some artists, I do not stretch my paper before painting. In the past I've spent a large amount of time soaking and stretching and stapling paper, only to ruin the painting within a few minutes. Instead I attach my dry paper to a rigid board, such as Gatorboard® or Masonite®, using clips. The paper will buckle under the moisture as you paint, but it will flatten out as it dries.

Working Surface

I usually work sitting at a table with my board at a slight incline. My palette is on the right (I am right-handed), and my water container and paper towels are in the lid of my palette. I illuminate my work area with both fluorescent and incandescent bulbs for a neutral light. I make sure there is enough room in my workspace to stand back and check the composition, value, and balance during the painting process.

Other Necessities

To complete your studio setup, you will need the following: a water container (one that is deep with a large opening), a spray bottle (for keeping your paints moist), paper towels, a permanent or semi-permanent sketch pen, an HB pencil, an eraser, and a plastic scraping tool.

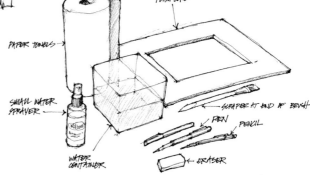

PAINTING ON LOCATION

To me, the most exciting way to paint is on location. Whether sitting outside in your backyard on a cool fall after-noon or waiting at an airport gate, working directly from your subject enriches the painting experience. There is an immediacy and directness to your work that is sometimes hard to capture when working from photographs. I bring a complete studio wherever I go. I am always ready to paint when the mood strikes or if an interesting subject presents itself. I have identified a variety of travel setups below, from the minimum gear that accompanies me daily to the more elaborate setup that I take for serious painting trips. As you equip yourself for a location adventure, remember to keep it simple and pack light. The last thing you need is a lot of complicated and heavy stuff to lug around. You need to be ready to paint after only a few minutes of prep time.

Travel Boxes

I have a collection of travel boxes in a variety of sizes, but my favorite box contains paint, three mixing areas, a built-in water bottle, a water holder, and even a small paintbrush. It conveniently folds into a compact little travel unit. I removed the hard pans that came with it and replaced them with my tube paints of choice. This paint is very moist, so you have to squirt it a few days before you travel to give it a chance to harden slightly.

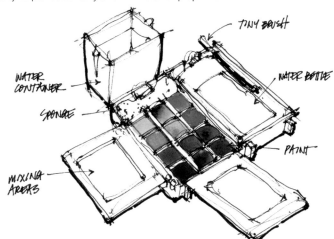

▶ **Preparing My Palette** My favorite travel box has space for 12 colors, so I had to edit my master palette. Here are the colors I chose: permanent alizarin crimson, Cadmium red light, permanent yellow-orange, new gamboge, greenish yellow, raw sienna, burnt sienna, burnt umber, ultramarine blue, phthalo blue, cobalt blue, and cerulean blue.

Travel Paintbrushes

It's easy to damage your nice brushes in transit, so I use a brush holder that protects the bristles. I also carry with me small and medium round brushes made specifically for travel, which have built-in protective caps. They are available with either sable or synthetic bristles.

Sketchbooks

When painting on location, I usually work in a sketch-book. I have a variety of sizes and types. For most paint-ing trips, I use either an 11-inch x 14-inch, 140-pound spiral-bound watercolor book or a 9-inch x 12-inch sketchbook. I also carry a 6-inch x 9-inch sketchbook for casual sketching and small studies. When I don't want to carry a bag, I use a 3.5-inch x 5-inch sketch-book that fits neatly in my back pocket. This, combined with my sketch pen, gives me a hands-free micro-studio. Of course, you can always take real watercolor paper with you, but keep it small and simple; a quarter sheet (10 x 14 inches) clipped to a board will do.

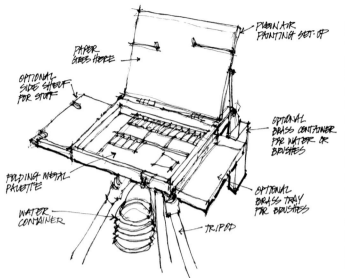

PLEIN AIR PAINTING SET-UP

PAPER GOES HERE

OPTIONAL SIDE SHELF FOR STUFF

OPTIONAL BRASS CONTAINER FOR WATER OR BRUSHES

FOLDING METAL PALETTE

WATER CONTAINER

OPTIONAL BRASS TRAY FOR BRUSHES

TRIPOD

Easel

To support your painting surface, you can use an official artist's easel, hold a sketchbook in your hand, or do something in between. I use all these methods. A half French easel provides a solid support for your work; the only drawback is its weight and the occasional challenge of setting up the wooden legs without pinching your fingers. You can also purchase an outdoor painting rig, such as the one shown at left, that attaches to a camera tripod. Make sure the setup has a place to hold your paper or sketchbook, palette, water, and brushes.

A friend of mine attached a block of wood with a threaded nutsert to the back of a piece of tempered Masonite®, which allows me to attach the board to my camera tripod. The paper or sketchbook is clipped to the board. The swivel head on the tripod allows me to angle to board in any position, from vertical to flat.

The lightest easel I have is an inexpensive folding metal tripod. Because it requires a flat surface to sit on, you must work sitting down. Of course, if you want to go even lighter, just sit on the ground with your sketchbook in your lap.

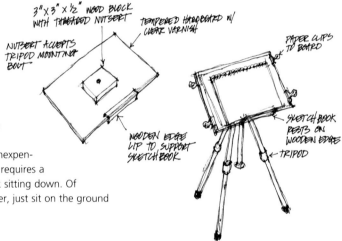

3" X 3" X ½" WOOD BLOCK WITH THREADED NUTSERT

NUTSERT ACCEPTS TRIPOD MOUNTING BOLT

TEMPERED HARDBOARD W/ CLEAR VARNISH

PAPER CLIPS TO BOARD

WOODEN EDGE LIP TO SUPPORT SKETCHBOOK

SKETCHBOOK RESTS ON WOODEN EDGE

TRIPOD

Other Necessities

Some additional items you will need on site include the following: a water container, a spray bottle, paper towels, a pencil, a pen, an eraser, a light-weight camp stool, and a small digital camera for testing compositions.

On-Location Painting Tips

• *When you arrive, take time to look around and study the scene. Don't be too hasty to start painting. See what attracts you, then look at it from a few different vantage points.*

• *Savor the ambience. Smell the air and enjoy the beautiful colors and sounds.*

• *Find a comfortable spot with a good view. Although I like talking to people, I try to find a spot off the path and out of traffic.*

• *After making your thumbnail sketches and value studies, lay in your shadows. They are constantly changing, so it helps to lock them in right away.*

• *Keep it simple. Don't put in too much detail.*

• *Work quickly and loosely.*

• *Learn to "read" the weather. Your paper and paints will dry depending on the temperature and humidity. On a hot day, mist your paints often.*

• *There will be pleasant distractions (a soft, fragrant breeze; a dog barking in the distance; an airplane overhead; chirping birds; and curious people) as well as not-so-pleasant ones (heat, a cold wind, rain, an annoying dog that won't stop barking, insects, and curious people). Try to take it all in as part of the experience and roll with it.*

COLOR RELATIONSHIPS

I love color, and I love using it as a means to express myself in my paintings. I never let reality stand in the way of a good painting, either. If I think a splash of red would look good in a palm tree, I put it in. A bright purple shadow? No problem! People coming to a concert in bright jump suits? Okay! As artists, we are supposed to interpret what is there and express it. Some do it very realistically, and others do it impressionistically.

A fundamental knowledge of color can assist us in clearly expressing what we see and what we want to say. We can communicate feelings, mood, time of day, seasons, and emotions with color. Gaining knowledge of how colors work and work together is the key to refining our ability to communicate with color.

I am a big believer in experimentation. I would rather fool around with different colors than conduct an exhaustive analysis of color theory. However, a few general concepts are worth mentioning. In this section, I will give you some basic guidelines and hints that will assist you in your own experimentation.

The Color Wheel
A *color wheel* is a visual representation of colors arranged according to their chromatic relationship. The basic color wheel consists of 12 colors that can be broken down into three different groups: primary colors, secondary colors, and tertiary colors.

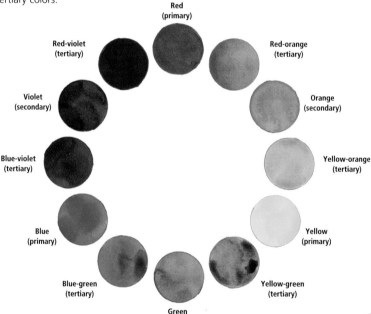

Red
(primary)

Red-violet
(tertiary)

Red-orange
(tertiary)

Violet
(secondary)

Orange
(secondary)

Blue-violet
(tertiary)

Yellow-orange
(tertiary)

Blue
(primary)

Yellow
(primary)

Blue-green
(tertiary)

Yellow-green
(tertiary)

Green
(secondary)

Primary Colors
The primary colors are red, yellow, and blue. These colors cannot be created by mixing any other colors, but in theory, all other colors can be mixed from them. The primary colors in my personal palette are Cadmium red light, new gamboge, and cobalt blue.

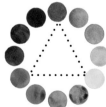

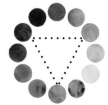

Secondary Colors
Secondary colors are created by mixing any two primary colors and are found in between the primary colors on the color wheel. Orange, green, and purple are secondary colors. In my palette, the secondary colors are permanent yellow-orange, olive green, and mineral violet.

Tertiary Colors

If you mix a primary color with its adjacent secondary color, you get a tertiary color. These colors fill in the gaps and finish the color wheel. Tertiary colors are red-orange, red-violet, yellow-orange, yellow-green, blue-green, and blue-violet. I have to mix most of my tertiary colors, but some come right from the tube.

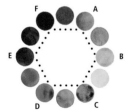

A. Red-orange: Cadmium red light + permanent yellow-orange

B. Yellow-orange: permanent yellow-orange + new gamboge

C. Yellow-green: greenish yellow

D. Blue-green: phthalo blue + greenish yellow

E. Blue-violet: ultramarine blue + mineral violet

F. Red-violet: alizarin crimson

My Colors

The color wheel at right contains all the pigments in my palette, which I've placed in the most appropriate spots as they relate to the color wheel on page 10. As you can see, a few colors are outside the basic circle, although I have located them in the general neighborhood.

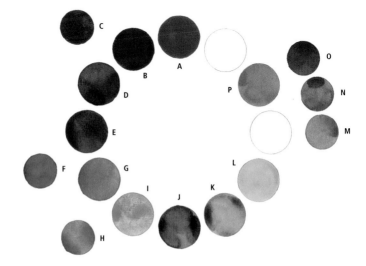

A. Cadmium red light: a bright, opaque red
B. Permanent alizarin crimson: a cool, bluish red
C. Opera: a bright, fluorescent magenta
D. Mineral violet: a pre-mixed purple
E. Ultramarine blue: a reddish, deep blue
F. Phthalo blue: a brilliant blue-green
G. Cobalt blue: a neutral blue, perfect for shadows
H. Cerulean blue: a pale, grayed-down blue

I. Cobalt turquoise: an opaque blue-green
J. Olive green: a warm, organic green
K. Greenish yellow: a bright green
L. New gamboge: a brilliant yellow with a touch of red
M. Raw sienna: a warm, grayish yellow
N. Burnt sienna: a warm, reddish brown
O. Burnt umber: a deep chocolate brown
P. Permanent yellow-orange: a pure orange

Creating Wheel References

One of the best lessons I was taught in art school was making a complete 12-color color wheel with just the three primaries: red, yellow, and blue. It made me realize that all colors are derived from just these three. I use many more colors now because some colors and accents are very difficult and time-consuming to mix. I also suggest that you mix a color wheel with both the primaries and secondaries in your palette. This can help you understand how to create additional colors, see how colors interact, indicate if you have too many colors (do you really need five reds?), and see your palette of colors in spectrum order.

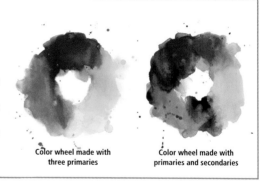

Color wheel made with
three primaries

Color wheel made with
primaries and secondaries

Color Schemes

Choosing and applying a *color scheme* (or a selection of related colors) in your painting can help you achieve unity, harmony, or dynamic contrasts. This page showcases a variety of common color combinations. Explore these different schemes to familiarize yourself with the nature of color relationships and to practice mixing colors.

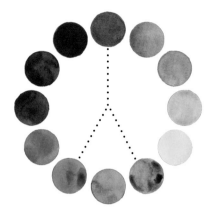

▲ **Split-Complementary Color Schemes** This scheme includes a main color and a color on each side of its complementary color. An example of this (shown above) would be red, yellow-green, and blue-green.

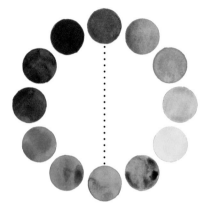

▲ **Complementary Color Schemes** Complementary colors are colors that are opposite each other on the color wheel. Red and green (shown above), orange and blue, and yellow and purple are examples of complementary colors. When placed adjacent to each other in a painting, complements make each other appear brighter. When mixed, they have the opposite effect, neutralizing (or graying) each other.

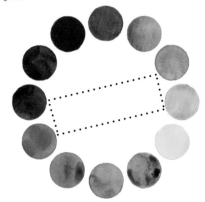

▲ **Tetradic Color Schemes** Four colors that form a square or a rectangle on the color wheel create a tetradic color scheme. This color scheme includes two pairs of complementary colors, such as orange and blue and yellow-orange and blue-violet (shown above). This is also known as a "double-complementary" color scheme.

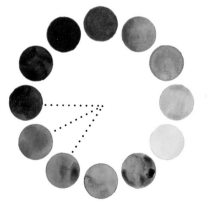

▲ **Analogous Color Schemes** Analogous colors are adjacent (or close) to each other on the color wheel. Analogous color schemes are good for creating unity within a painting because the colors are already related. You can do a tight analogous scheme (a very small range of colors) or a loose analogous scheme (a larger range of related colors). Examples of tight analogous color schemes would be red, red-orange, and orange; or blue-violet, blue, and blue-green (shown above). A loose analogous scheme would be blue, violet, and red.

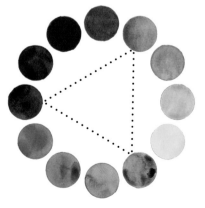

▲ **Triadic Color Scheme** This scheme consists of three colors that form an equilateral triangle on the color wheel. An example of this would be blue-violet, red-orange, and yellow-green (shown above).

Color Temperature

Divide your color wheel in half by drawing a line from a point between red and red-violet to a point between yellow-green and green. You have now identified the *warm colors* (the reds, oranges, and yellows) and the *cool colors* (the greens, blues, and purples). Granted, red-violet is a bit warm and yellow-green is a bit cool, but the line needs to be drawn somewhere, and you'll get the general idea from this. In a painting, warm colors tend to advance and appear more active, whereas cool colors recede and provide a sense of calm. Remember these important points about color temperature as you plan your painting.

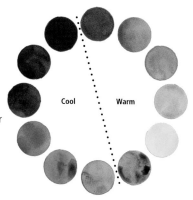

Cool Warm

Color Properties

The properties of color are hue, value, and intensity. When you look at a color, you will see all three properties. *Hue* is the name of the color, such as red, yellow, or blue. *Value* refers to how light or dark a color is. *Intensity* is the color's brightness or dullness.

Hue

Hue is the color name. There are many blue hues in my palette. Each one is slightly different. The following are all the blue hues in my palette.

Phthalo blue: a greenish blue **Cobalt turquoise light: a bright, greenish blue** **Cerulean blue: a bright, grayish blue** **Ultramarine blue: a cool, reddish blue** **Cobalt blue: a pure blue**

Value

Value refers to the lightness or darkness of a color (or of black). Variations of color values are an important tool for creating the illusion of form and depth in your paintings. Colors have their own inherent value; squint at a color wheel and you'll see light colors, such as yellow, and dark colors, such as purple. In addition, each color has its own range of values. With watercolor, add water to lighten the value (creating a *tint* of the color), or add black to darken the value (creating a *shade* of the color).

Purple **Yellow** **Red** **Green**

Purple (grayscale) **Yellow (grayscale)** **Red (grayscale)** **Green (grayscale)**

◄ **Assessing the Value of Color** At left you'll see colors from the color wheel (top row) and how they appear in grayscale (bottom row). Viewing them in this manner reveals the true value of each color without any visual distractions. As you can see, purple is very dark, yellow is very light, and red and green are similar medium values.

◄ **Creating Value Scales** Get to know the range of lights your paint colors can produce by creating a few value scales. Working your way from left to right, start with a very strong wash of your color and add more water for successively lighter values.

Intensity

Intensity refers to the purity (or saturation) of the color. Colors right out of the tube (or as they appear on the color wheel) are at full intensity. To change the intensity of watercolor paint, you can dull the color (or gray it) by adding its complement, gray, black, white, or water. Although adding black or water changes the value of the color, it also neutralizes it, dulling it and making it less intense.

Ultramarine blue right out of the tube at full intensity **Ultramarine blue dulled with water** **Ultramarine blue dulled with burnt umber**

COLOR MIXING

Painting with transparent watercolors is a unique and enjoyable experience because of the way the colors can be mixed. Other types of paint (especially oil) are usually mixed on a separate palette and then applied to the canvas. They are also mixed additively; in other words, white pigment is added to lighten the colors. In contrast, transparent watercolor relies on the white of the paper and the translucency of the pigment to communicate light and brightness. A well-painted watercolor seems to glow with an inner illumination that no other medium can capture.

The best way to make your paintings vibrant and full of energy is to mix most of your colors on the paper while you are painting the picture. This is somewhat counterintuitive, based on what most of us were taught. In school, you most likely mixed a pool of color in your palette, adding this or that until you reached the desired shade; then you applied it to the paper. No doubt you created some great colors, and there is nothing wrong with this style of painting. I suggest, however, that allowing the colors to mix together on the paper, with the help of gravity, can create even more dynamic results. It is accidental to a certain degree, but if your values and composition are under control, these unexpected color areas will be very exciting and successful. On these pages, you'll learn all the techniques I use for color mixing on the paper.

Wet on Dry

This method involves applying different washes of color on dry watercolor paper and allowing the colors to intermingle, creating interesting edges and blends. This is the technique I usually use when I paint. It is difficult and somewhat scary, though—you don't always know how it will turn out!

▶ **Mixing in the Palette vs. Mixing Wet on Dry** To experience the difference between mixing in the palette and mixing on the paper, create two purple shadow samples. Mix ultramarine blue and alizarin crimson in your palette until you get a rich purple; then paint a swatch on dry watercolor paper (near right). Next paint a swatch of ultramarine blue on dry watercolor paper. While this is still wet, add alizarin crimson to the lower part of the blue wash, and watch the colors connect and blend (far right). Compare the two swatches. The second one (far right) is more exciting. It uses the same paints but has the added energy of the colors mixing and moving on the paper. Use this mix to create dynamic shadows.

◀ **Mixing a Tree Color** Next create a tree color. First mix green in your palette using phthalo blue and new gamboge, and paint a swatch on your paper (far left). Now create a second swatch using a wash of phthalo blue; then quickly add burnt sienna to the bottom of this swatch. While this is still wet, add new gamboge to the top of the swatch. Watch these three colors combine to make a beautiful tree color that is full of depth (near left). Compare this with the flat wash you mixed in your palette (far left).

Variegated Wash

A *variegated wash* differs from the wet-on-dry technique in that wet washes of color are applied to wet paper instead of dry paper. The results are similar, but using wet paper creates a smoother blend of color. Using clear water, stroke over the area you want to paint and let it begin to dry. When it is just damp, add washes of color and watch them mix, tilting your paper slightly to encourage the process.

Applying a Variegated Wash After applying clear water to your paper, stroke on a wash of ultramarine blue (left). Immediately add some alizarin crimson to the wash (center), and then tilt to blend the colors further (right). Compare this with your wet-on-dry purple shadow to see the subtle differences caused by the initial wash of water on the paper.

Wet into Wet

This technique is like the variegated wash, but the paper must be thoroughly soaked with water before you apply any color. The saturated paper allows the color to spread quickly, easily, and softly across the paper. The delicate, feathery blends created by this technique are perfect for painting skies. Begin by generously stroking clear water over the area you want to paint, and wait for it to soak in. When the surface takes on a matte sheen, apply another layer of water. When the paper again takes on a matte sheen, apply washes of color and watch the colors spread. For variation in the blends and shapes of my skies, I don't pre-wet the entire sky area; instead I dab around a little with clean water, loosely following my pencil sketch.

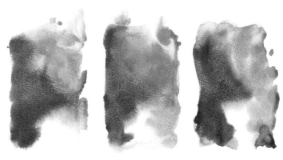

Painting Skies Wet into Wet Loosely wet the area you want to paint. After the water soaks in, follow up with another layer of water and wait again for the matte sheen. Then apply ultramarine blue to your paper, both to the wet and dry areas of the paper. Now add a different blue, such as cobalt or cerulean, and leave some paper areas white (left). Now add some raw sienna (center) and a touch of alizarin crimson (right). The wet areas of the paper will yield smooth, blended, light washes, while the dry areas will allow for a darker, hard-edged expression of paint. This variation creates some very unexpected skies.

Glazing

Glazing is a traditional watercolor technique that involves two or more washes of color applied in layers to create a luminous, atmospheric effect. I like to use glazes for sunset and night scenes, applying a number of washes with increasingly more pigment added in each one. The glazing unifies the painting by providing an overall *underpainting* (or background wash) of consistent color.

Creating a Glaze To create a glazed wash, paint a layer of ultramarine blue on your paper. (Your paper can either be wet or dry.) After this wash dries, apply a wash of alizarin crimson over it. The subtly mottled purple that results is made up of individual glazes of transparent color.

Charging In Color

This technique involves adding pure, intense color to a more diluted wash that has just been applied. The moisture in the wash will grab the new color and pull it in, creating irregular edges and shapes of blended color. This is one of the most fun and exciting techniques to watch—anything can happen!

Creating a Charged-In Tree Color First apply a wash of phthalo blue (left); then load your brush with pure burnt sienna and apply it to the bottom of the swatch (center). Follow up with pure new gamboge on the opposite side, and watch the pigments react on the paper (right). Remember that pigments interact differently, so test this out using several color combinations.

Testing Your Habits

A good way to tell if you are mixing on the paper is to look at your palette after a painting is done. If there are muddy pools of color on your palette, chances are that your painting is also lacking in clear, distinct colors (near right). If your palette still has separate pools of color on it, good job! You are mixing on the paper (far right).

 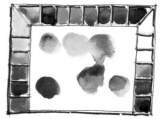

PIGMENT PROPERTIES

In addition to the wide variety of colors we can use to tell our story, the colors themselves have special properties that make for some exciting accidents and unexpected effects. Originally, paint pigments came from organic sources (that is, from something living). Although most paint pigments these days are synthetic, some still have an organic base. These organic pigments make up the most transparent paints and express the most clarity of color. Other pigments have a staining effect and are almost impossible to remove once they have dried on the paper, but they can be used as an underpainting with dazzling effects. Some pigments are opaque and do not have the lucid transparency of the organic paints. Other pigments granulate when applied, creating texture as the pigment particles separate. (For more on granulation, see page 17.)

The point here is that different pigments act and react differently as they interact with the paper, water, and other pigments. Although I think it a worthy exercise to paint swatches with different combinations, you could easily spend all your time conducting exhaustive studies and never get around to painting! Try a few of these examples just to get a feel for the paint. Then go paint a picture, and learn by doing and having fun.

Note: In researching this book, I noticed some inconsistencies with regard to the qualities of different pigments. Some sources identify certain paints as opaque, while others list the same color as staining. The information below is based on my experiences and how I use paint. I encourage you to experiment and explore.

Transparent Pigments

All watercolor pigments are transparent if mixed with enough water. You can even do a transparent painting with acrylics or oil paint! I mentioned earlier that for this book, my palette consists mostly of transparent watercolors as opposed to opaque (gouache) watercolors. Even within our category of transparent watercolors, some are classified as specifically transparent. These colors are perfect for glazing because they allow the white of the paper and the color from the previous wash to show through. These colors are relatively easy to lift off after they have dried on the paper. Their transparency allows them to be used as a unifying glazing wash over an overly busy painting. Cobalt blue is perfect for this, as well as for making luminous shadows across buildings and streets in the late afternoon. Below are the transparent pigments in my palette.

Gamboge

Greenish yellow

Cobalt turquoise light

Cobalt blue

Mineral violet

Staining Pigments

Staining colors contain pigments that have been ground to submicron particle size. They will stain anything and everything, from your paper to your palette, and can be scary until you get used to them. Staining pigments are perfect for an initial wash of strong color because they show through subsequent glazing washes with bright clarity. My staining colors are shown below.

Alizarin crimson

Cadmium red light

Phthalo blue

Opera

What Mixes Well?

Be extra careful when mixing cadmiums and other opaque colors. They go from pretty to lifeless in an instant. I have found that mixing on the paper allows each color to express its best qualities most effectively; colors are distinct and brilliant, and you can avoid potentially bad mixes. Use pure color applied to the paper without pre-mixing.

Sedimentary Pigments and Granulation

Sedimentary colors contain pigments that have been ground into particles that are larger than those in staining pigments. The paint particles separate and settle into the valleys of the paper. When this happens, it is called granulation and is a natural property of some of the denser pigments. Use these colors for showing texture and rawness in an area of a painting. The best examples of this are ultramarine blue and cerulean blue.

Cerulean blue

Ultramarine blue

Raw sienna

Burnt sienna

Burnt umber

Opaque Pigments

Some colors contain pigments that have been ground into very small, densely packed particles that allow little space for the white of the paper or an underpainting of color to shine through. Use these colors to paint over washes of staining colors. Use care, however. These colors are beautiful, but if applied too heavily they will lose their brightness and vibrancy and become dull, thick, and dead. Ouch!

Cadmium red light

Permanent yellow-orange

Cerulean blue

Titanium white

Creating Grays and Neutrals

I use gray with caution. Most of my paintings are full of bright, pure color. Even my shadows are loaded with color. I suppose I would even put color on a moody day painting. And that's the key: using color in your grays. Whenever you want to neutralize a color, add its complement. But please remember to mix it on the paper for a colorful neutral. Here are a few ways to mix some beautiful grays.

Ultramarine blue with a little burnt umber for a rich, cool gray

Burnt umber with a little ultramarine blue for a warm gray

Cerulean blue with burnt sienna for a different warm gray

You can mix a beautiful gray with ultramarine blue and burnt umber. The chart below shows a spectrum of cool to warm grays, all mixed with these two colors. Start with pure ultramarine blue in the first square and gradually add increasing amounts of burnt umber in subsequent squares. The last square should be pure burnt umber.

Special Color Mixes

These are some of my favorite mixes, developed over time and with many "practice" paintings. The best results are obtained if the colors are left a little unmixed on the painting.

Ultramarine blue and alizarin crimson (deep shadow purple)

Ultramarine blue and burnt umber (cool/warm gray)

Phthalo blue and burnt umber (cool dark green)

Phthalo blue and new gamboge (bright green)

Cobalt blue and opera (bright shadow purple)

Cerulean blue and burnt sienna (warm gray)

Cadmium red light and new gamboge (orange)

Burnt sienna and new gamboge (brown)

COLOR & VALUE

My friend Marilyn Simandle (a great watercolorist and oil painter) told me that color gets all the credit, but value does all the work. I have shared this with all my classes ever since. We respond to the strong values in a painting, but we tend to say, "What pretty colors."

For most paintings to be successful, there should be a good value pattern across the painting, which means a clear and definite arrangement of dark, middle, and light values. This will create an effective design, which appeals to our innate sense of aesthetics and what is pleasing to the eye. It also helps communicate the point of your painting in a clear and uncluttered manner. Keep in mind that these values should not be equal in a painting but rather predominantly light or dark. Equal amounts of light and dark result in a static image that lacks movement, drama, and—most important—interest.

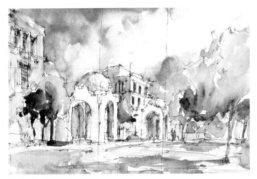

Predominantly light painting

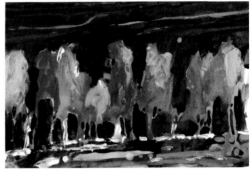

Predominantly dark painting

A good exercise is to make a black-and-white print of your painting. Does it read well? Can you see a separation of elements and objects without having to rely on the colors? If so, good job—your values are working for you. Too often we rely on the colors to get the point across, and we are disappointed when it doesn't happen.

To demonstrate the importance of value, I've painted the same scene three times (see below). At far left, I painted it using the appropriate colors and values. Then I painted the scene twice more: once using the correct colors but values that are similar to one another (center) and once using the correct values but all the wrong colors (right). Which of these two makes a better painting—the image at center or the image at right? I vote for the one with the correct values (right).

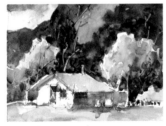

Correct colors, correct values

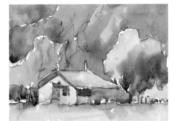

Correct colors, incorrect values

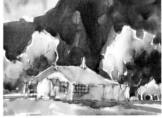

Incorrect colors, correct values

Charting the Values of Your Palette

This chart shows the relative values of each color in my palette. To do this for your palette, first create a gray value scale of ten steps (shown along the bottom). Then create and cut out a swatch of each color in your palette. Squint at your swatches, helping your eyes drop the colors and reduce them to shades of gray. Then gauge their values against the scale you created. For example, new gamboge is a light value, opera a medium value, and phthalo blue a dark value. Knowing where the general value of each color falls on the scale can help you know which colors to combine to create effective patterns of value.

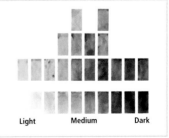

Light Medium Dark

THUMBNAIL SKETCHES

Look across the room the next time you are at an art show or in a gallery. What stands out as the best painting? I will venture to say that it is not the biggest one, nor is it the one with the best technique, color, or subject matter. I suggest that it is the one with the best value pattern, the simplest design, and the strongest composition. One way to ensure that your piece will be strong in these areas is through the use of thumbnail sketches. A *thumbnail sketch* is a quick, tiny drawing about the size of a postage stamp. (The size of my thumbnail is a little too small.) I do a series of these to prepare for each painting, exploring different compositions and value patterns. As I create the thumbnails, I am also exploring how to simplify my scene to make a strong, clear expression of the focus of my painting.

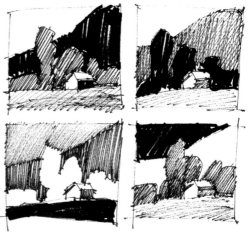

▲ **Creating Value Thumbnails** I use no more than four distinct values for these sketches: dark, medium, light, and white (the paper). It's a challenge to work at such a small size because I am forced to work simply and eliminate detail. However, the process of paring down the composition to a value-only state enables me to view my piece as a design, which is more difficult to judge at a larger size. After I have done a few thumbnails, I select one that is simple with a dramatic value pattern. In this case, I chose the sketch at the upper left, which suggests a dramatic lighting scheme. This sketch becomes a "roadmap" for my larger painting. The composition and values have been worked out—I know where I am going. Now I can be free to explore colors and paint with abandon, as long as I follow the values.

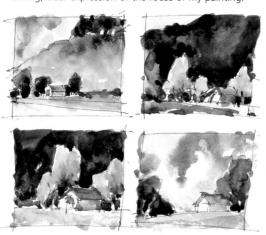

▲ **Painting Color Studies** Another avenue of exploration you can take in the thumbnail stage is that of color thumbnails. After your values have been established and you have an overall sense of the colors, do a series of small line sketches in pen and ink and then add color. This is another planning tool that helps you practice your painting.

▶ **Moving Forward** Here is a final painting that resulted from my thumbnails. But remember, you don't have to come to one conclusion; this is just one of four final paintings I derived from these studies.

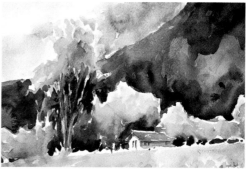

Thumbnail Tips

- *Work quickly and without detail.*
- *Establish the values across the composition.*
- *Make distinct value differences; white, light, medium, and dark.*
- *Don't just scribble around; be clear with your shapes.*
- *Try different media, such as pencil, pen and ink, or watercolor.*

- *After you have developed a value/composition pattern, apply color in a "value sense."*
- *Follow this as your roadmap for the final painting. The hard decisions have been made—now paint with reckless abandon.*
- *Finally, don't be a slave to your sketch; if something accidental happens and looks good, go with it.*

FOCAL POINT

A *focal point,* also called the "center of interest," is the part of the painting you look at first. Some artists do not believe in a focal point but feel that all parts of a painting are of equal importance. I disagree; I like to have a clear focal point—a main idea, a reason I did the painting in the first place—and think it is essential for achieving a pleasing composition.

In a painting, color and contrast play huge roles in determining the focal point. For example, imagine a painting of a tree in late summer. It is covered with leaves in all shades of green and yellow. There is a bright orange leaf in the corner. Where do you think your eye will go? It will most likely move to the orange leaf—your focal point. Below are guidelines for using color to guide the viewer's eye to your intended center of interest.

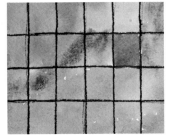

Complementary Colors Set off your focal point from the background by using a complementary color scheme (for example, a red object in a sea of green).

Color Temperature Place a warmly colored object against a cool background to make it "pop."

Color Accent Add splashes of pure, bright color to a generally muted painting.

Attracting the Eye

Color isn't the only device for guiding the viewer's eye in a painting. Contrast in general—from shape to value—is an invaluable tool. Below are some points to keep in mind as you select and place your focal point.

▶ **Shape Contrast** Place a smooth object against a background of irregular shapes (or vice versa). Or try juxtaposing a vertical line against a predominantly horizontal painting (or vice versa).

▶ **Value** Placing the darkest dark against the lightest light creates an irresistible contrast.

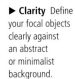

▶ **Position** Divide your page into thirds, both horizontally and vertically. Where two of those lines cross is a good spot for a focal point. This is often called the "rule of thirds."

▶ **Clarity** Define your focal objects clearly against an abstract or minimalist background.

Avoid the center of the picture for the focal point. In most cases, the center is the "dead zone" for the placement of objects and can make your composition feel static.

ATMOSPHERIC PERSPECTIVE

As artists, we are magicians and deceivers; at least that's what we *should* be. We are trying to convince the viewer that a two-dimensional image (our painting) is three-dimensional (our subject). To achieve this goal, we need to simulate depth and distance in our paintings. Generally speaking, the farther away things are, the more the effects of the atmosphere become apparent. Particles in the air interfere with our perception, which causes loss of contrast, detail, and focus. Referred to by Leonardo DaVinci as the "perspective of disappearance," this phenomenon is known today as "atmospheric (or aerial) perspective." According to this principle, objects take on a cooler, blue-gray middle value as they recede into the distance. What does that mean to us as watercolor artists? Here are a few color notes to remember in planning a painting:

Distant Objects

1. Colors are muted and less intense.

2. Colors are cooler.

3. Colors tend to be bluer, grayer, and have more middle values.

4. There is less contrast.

5. Shadows are paler.

6. Detail is minimized.

Close Objects

1. Colors are brighter and more intense.

2. Colors are warmer.

3. Colors have lighter lights and darker darks.

4. There is more contrast.

5. Shadows are deeper, richer, and have more color.

6. Detail is maximized.

In addition to using color, we can enhance and even force this perception of space and distance by paying particular attention to the following visual cues:

Size Objects in the distance appear smaller than objects in the foreground.

One-Point Perspective Vertical and horizontal lines appear closer together as they move toward the horizon.

Overlapping Placing objects in front of other objects will help produce the illusion of distance.

Detail Objects in the distance have less detail and appear subtler than closer objects.

Focus Objects that are far away appear slightly out of focus.

Temperature Foreground objects are warmer in tone. As objects recede, they become cooler.

MOOD & TEMPERATURE

We are all affected by color, regardless of whether we realize it. Studies show that color schemes make us feel certain ways. Warm colors, such as red, orange, yellow, and light green, are exciting and energetic. Cool colors, such as dark green, blue, and purple, are calming and soothing. Use these colors schemes as tools to express the mood of the painting. In fact, you'll find that you don't even need a subject in your painting to communicate a particular feeling; the abstract works below demonstrate how color is powerful enough to stand on its own.

Warm Palette What is this painting of? Who knows! It doesn't matter. The point here is to express a mood or a feeling. Here the mood is hot, vibrant passion. Energetic reds and oranges contrast the cool accents of blue and purple.

Cool Palette A much different feeling is expressed in this painting. It is one of calm and gentle inward thought. The red-orange accents create an exciting counterpoint to the overall palette of cool greens and blues.

Suggesting Mood with Strokes

Color isn't the only thing that affects mood. All parts of the painting contribute to the mood of the piece, including the brushstrokes and linework. Keep these points in mind as you aim for a specific feeling in your paintings.

▶ Upward strokes (heavier at the base and tapering as they move up) suggest a positive feeling.

▶ Downward strokes (heavier at the top and tapering as they move down) suggest a more somber tone.

▶ Vertical strokes communicate force, energy, and drama.

▶ Horizontal strokes denote peace and tranquility.

In addition to warm and cool palettes, bright and dark palettes also work well for conveying a mood. A bright palette consists of light, pure colors with plenty of white paper showing through. This gives the effect of clean, positive, uplifting energy. Darker, saturated colors covering most of the paper suggest a more serious tone—a mood of quiet somberness and peace.

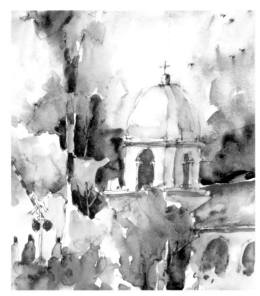

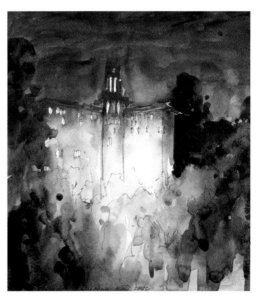

Bright Palette The pure, warm colors with plenty of white paper showing through expresses the cheer of this light-hearted scene. Complementary colors (e.g., red against green or yellow against purple) also help enliven the story.

Dark Palette The darker colors in the cool range communicate a heavier mood. Here I used an analogous color scheme of cool, darker colors to indicate the quiet end of the day and the approaching night.

A painting should be primarily one temperature—either warm or cool. I stick to this for the same reason I don't bisect my composition with a horizon line or include the same amount of lights and darks in my painting. There should be a clear, simple message in each painting with a minimum of variables. Also, you don't want to confuse the viewer with uncertainty. However, warm accents in a cool painting (and vice versa) are certainly acceptable and encouraged. Remember, you want your statement to be exciting but clear.

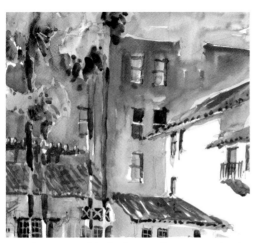

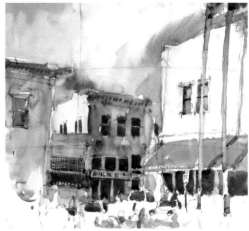

Accenting Warm and Cool Palettes In these two examples, I have used either warm or cool colors almost exclusively. The warm painting (left) suggests a hot summer day with energy in the air, and the cool painting (right) recedes into quiet and suggests a winter afternoon. Notice that in each case, I use complementary accents to emphasize the color theme with contrast.

TIME OF DAY

Light and shadow play a vital role in suggesting the time of day in a painting. The color temperature of light changes during the day, going from cool, light yellow in the morning to harsh white during the middle of the day. As the day passes, the light changes to a golden hue and turns to red before resolving into the cool evening colors of purple and blue. Your palette should respond to these changes in light. The shadows in your scene offer another way to communicate the time of day; for example, long, cool shadows are characteristic of morning, whereas short, colorless shadows evoke a midday feel. The examples on this page show how I generally treat light and shadow to suggest five different times of day.

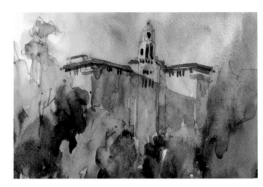

Sunrise At sunrise, everything has a fresh, warm cast. As the cool night gives way to morning, colors are primarily yellow. Shadows are long and cool blue in color. I used a complementary color scheme in this example, pitting the yellow-orange of the morning sun against the blue-purple of night shadows.

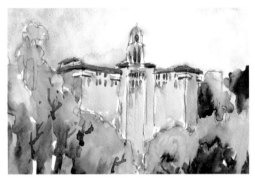

Midday At midday, the sun is directly overhead (at least in the summer), and all the colors are warm but washed out. There is little depth and interest in the colors. Shadows are basically non-existent. I emphasize the brightness by allowing plenty of bright white paper to show through.

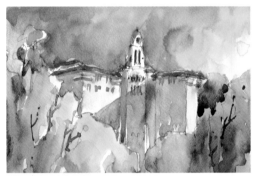

Sunset As sunset approaches, colors take on a golden cast, and shadows once again lengthen. As gold turns to orange and red, the shadows become warmer and redder. Colors once again become deep and rich. Sunset is similar to sunrise, but the colors have a warmer (redder) cast.

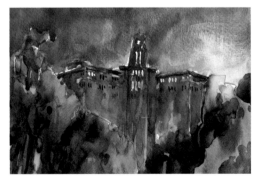

Dusk At dusk, everything becomes cool and dark. The sky still has a little light at the horizon, but it is primarily purple, deepening to blue. All objects appear as silhouettes rendered in dark blues, purples, and dark reds. Because there is no real light source, there is no shadow.

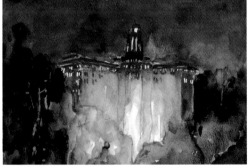

Night At night, all the light comes either from city light reflected in the sky, from street lights, or from building windows. The sky is a dark blue-black. Light comes from windows as bright white (the paper), changing to yellow, then red, then purple, and finally to blue to meld with the deep tones of nightfall. Here the base of the building is illuminated, as are the windows.

SEASONS

In addition to conveying the mood and time of day of a painting, the temperature of colors can help you communicate a specific season. Generally speaking, a warm landscape painting will suggest summer and fall, while a cool painting suggests and winter and spring. Think of it as following the colors of the leaves. Of course, there are other factors to take into account that will communicate the seasons, such as the subject (stark, bare trees of winter as opposed to the lush, full trees of summer), but the sensitive use of color can further enhance the atmosphere you want to project.

Spring For a springtime painting, I generally use bright, light blues for the sky and bright yellows and greens for the trees, with accents of red for fun. I use a cool cobalt blue to render the shadows.

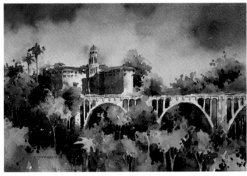

Summer My summertime skies feature deep blues with a touch of purple for the sky; deep, rich greens with bright yellow for trees and foliage; and reddish accents for the trees. The shadows of this season call for a warmer blue (ultramarine) with some purple for warmth.

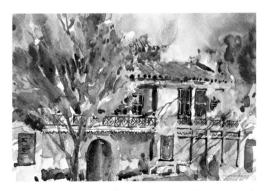

Fall Painting autumn allows for the explosion of reds, oranges, and yellows, with some complementary green in the trees for contrast. I represent the sky (and the shadows) with a warm blue that is warmed up even more with some purple and raw sienna.

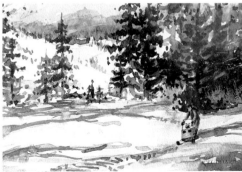

Winter A winter painting calls for all cool (and muted) colors: cool gray blue in the sky, and cool dark green and gray with touches of purple for the trees. I often throw some raw sienna in the foreground for a little warmth.

This section will show you how to use color to render specific elements. As always, expression is the key. I say "expression" because the color as it relates to the subjects becomes irrelevant. Trees don't have to be green; skies don't have to be blue. We can paint a painting with any colors we want, regardless of reality. Try to push color to the point of uncomfortability. I find that the further out I go with expression, the more exciting the painting becomes.

SKIES

What is the key element in painting an exciting sky? Color, of course! I prefer a variety of colors in my skies: blue, purple, red, yellow, white, gray, and brown, at the very least. Even on a clear day, I will use at least three blues, including ultramarine blue, cobalt blue, and cerulean blue or cobalt turquoise light. Alizarin crimson provides a warm accent (if used judiciously), as does raw sienna. For cloud shadows, mix ultramarine blue with burnt umber for a rich, cool gray. As you paint your skies, remember the following: leave some white space, don't over-paint, mix on the paper, allow room for accidents, and let gravity do the rest. The fluid medium of watercolor makes painting skies easy. In fact, they practically paint themselves!

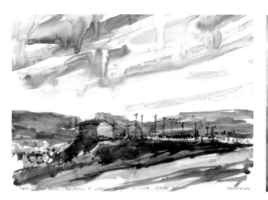

A Regular Summer Day This scene had a fairly nondescript sky. I made it more interesting by using long strokes of two blues—ultramarine and cerulean—and letting the colors mix on the paper. I added some extra water over my washes to encourage blending.

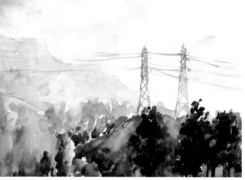

A Hazy, Bright Morning For this washed-out atmosphere, I used a very pale wash of cerulean blue with just a hint of gamboge to indicate the sun.

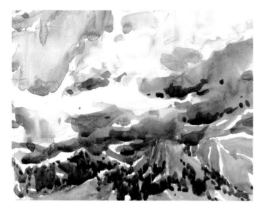

A Thunderstorm For this brooding scene, I indicated thunderheads surrounding a mountain using a surprisingly large amount of white paper. I just stroked on the shadows of the clouds using warm blues and grays mixed from ultramarine blue and burnt umber.

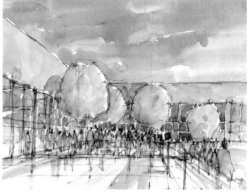

Approaching Rain This exciting weather calls out for a heavier sky treatment. I used dark washes of ultramarine blue and cobalt blue mixed with some alizarin crimson. I also slanted the page after applying washes to suggest the active sky.

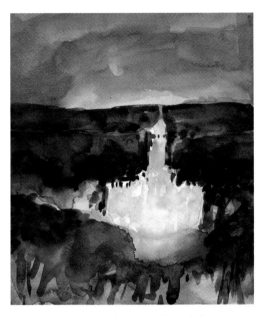

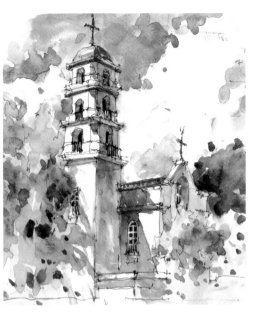

Evening Sky Rich washes of ultramarine blue with alizarin crimson give way to a hint of gamboge just at the horizon, where the white of the paper shows through.

Cloudy Summer Sky All I painted here is the area around the clouds. I used cobalt blue and cerulean blue to indicate the sky, and I used the white of the paper along with pale touches of cobalt blue, ultramarine blue, and raw sienna to suggest cloud shadows.

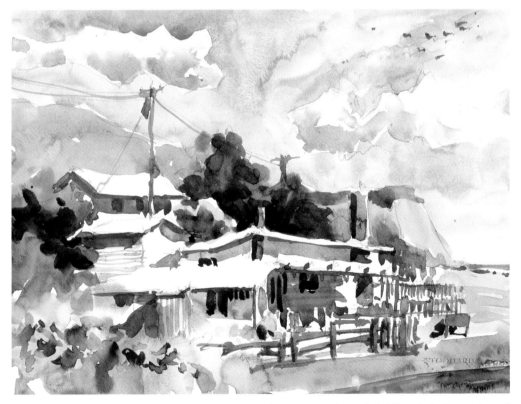

Peaceful Sky I indicated soft, harmless clouds by keeping the blue sky fairly pale with cerulean and cobalt blue. The clouds are a mixture of those same blues, with a touch of raw sienna to warm them up.

SUNRISES & SUNSETS

The key to painting an effective sunrise or sunset is the underpainting. The scene should have a blended wash beginning with white paper at the source (the sun) and proceeding across the page with yellow, orange, red, crimson, purple, and finally blue. This wash can be limited to the sky, but it doesn't have to be; I like having the colors bleed into the landscape whenever possible so the entire painting is bathed in the warm, golden tones of early morning or the reddish cast of late afternoon. Remember to make the shadows long and dramatic across the page in both sunrise and sunset scenes.

I always thought of sunset as being more intense and colorful than sunrises. In the morning, the cool of the night gradually gives way to the warm tones of dawn as a new day beacons. The color change is soft and gradual. At sunset, the daylight gives itself up reluctantly in an explosion of passionate color.

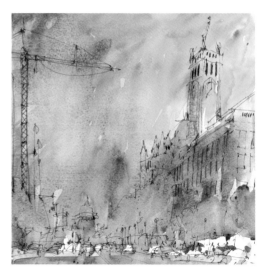

City Sunset Here I applied a wet-into-wet wash of gamboge, cadmium red, alizarin crimson, ultramarine blue, and cobalt blue over a pen-and-ink sketch. The structure of the piece relies on the drawing.

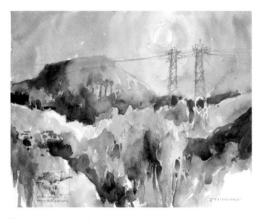

Eaton Canyon I used an analogous color scheme here to depict the early morning. White paper suggests the sun. Gamboge and olive green show trees bathed in golden light.

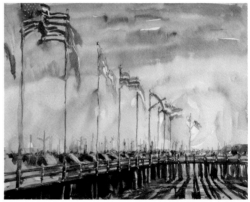

Santa Barbara Wharf Pale and muted colors indicate a hazy afternoon. I used a loose analogous color scheme to create minimum contrast.

Sunset in Washington, D.C.
Complementary colors yellow and purple give energy to this deceptively simple scene. The pure white paper suggests the last bit of bright sunlight as it moves behind the row of dark green trees.

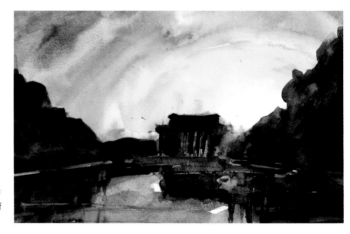

NIGHT

Night paintings yield dramatic and unexpected scenes. The environment has a completely different color palette after the sun goes down. Everything has a cool, dark blue and gray tone. Light comes from street lights and building windows to provide an emanating glow of warm colors.

Night painting is one of the few occasions where I use frisket to mask off light areas such as windows and lights. (For more on using frisket, see page 54.) This allows me to paint an underwash of glowing yellow starting at the main light source and gradually adding red and blue as I move away from the source. Creating this is similar to the sunset wash method. Feel free to use opaque white to highlight windows, stars, and other details. But as you paint your night scenes, remember to think simply in terms of composition, and keep detail to a minimum.

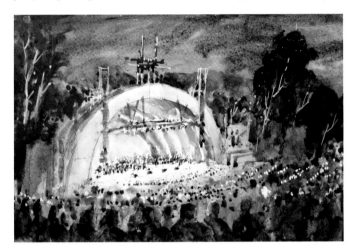

◄ **Hollywood Bowl** In this night scene of a concert at the Hollywood Bowl, I used a split-complementary color scheme: ultramarine blue with gamboge, orange, and red accents. In a typical night scene, the top of the sky is darkest (ultramarine with a touch of burnt umber), getting lighter as it nears the horizon, indicating the reflected lights of the city.

▼ **Lalo's Cocktails** As illustrated in this example, the night sky is always darkest at the top of the page, lightening as it nears the horizon due to reflected light from the city.

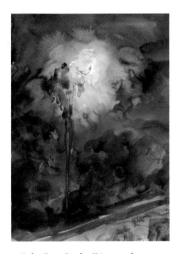

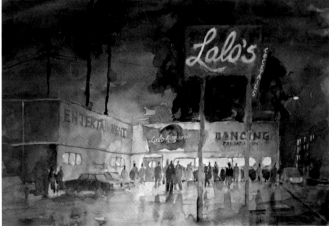

▲ **Palm Tree Study** This scene from my backyard features a palm tree silhouetted against the full moon in an otherwise black sky. To create this, I applied ultramarine blue and burnt umber heavily, using new gamboge behind the tree wet into wet.

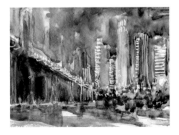

◄ **City at Night Study** In this quick study sketch, I suggested night by indicating an overall midtone blue and purple wash. I rendered the buildings in solid colors with titanium white accents indicating windows.

URBAN SCENES

When we think about cities and urban scenes, most of us think of browns, grays, and blacks—monochromatic and dull. But these bustling scenes are the perfect subject for interjecting loads of color. Skies should be bluer, and building colors should be exaggerated. If an object is a little on the pinkish side, make it bright red! Shadows should be dramatic and full of blues and purples. Trees should be bright green with accents of yellow. People and cars should be accented with vibrant colors. The more elements, the better—so throw in plenty of cars, people, telephone poles and wires, airplanes, and signs. Urban scenes involve plenty of texture and intricate divisions of space. However, remember to leave some white space to give the eye a rest and provide contrast with the busy scene.

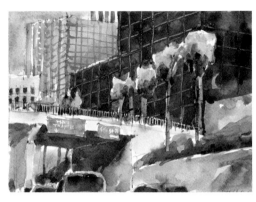

Through Traffic The strength of this scene is its simple, geometric composition accented with pairs of complementary colors.

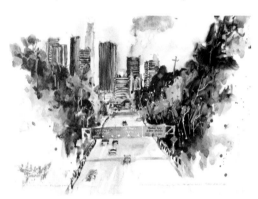

City Entrance There is no definite color scheme here—just plenty of pure, vibrant color to energize the scene.

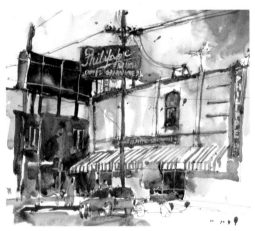

Restaurant Corner A tetradic color scheme highlights this scene. Raw sienna walls vibrate against the purple shadows, and the green trees resonate with the red stripes of the awning.

PEOPLE

Adding people to a scene is a great way to add life and energy to your painting—even a few random pedestrians in the corner can make a difference. To enhance this energy, I accent my people with bright colors. To make them stand out, I often paint them in a color complementary to that of the background color (i.e., yellow people against a purple shadow or red people against green trees).

I am a great proponent of what I call "blobular-shaped people." These forms are made with a single dab of the brush, followed by a tiny dot for the head. And the looser these forms are, the better. I have seen many beautiful paintings ruined by overly worked, overly detailed, stiff people.

▶ **Group of People** A group of brightly dressed patrons enliven this Los Angeles scene. The colors of the blobular people bleed together and blend into the background to unify the painting.

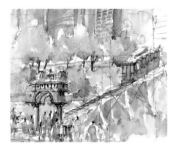

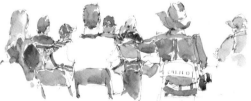

▲ **Close-Up Group** Loose washes of color work with a pen-and-ink drawing to suggest an audience. Use the white of the paper as a color.

SHADOWS

Although most of us think of gray or black when we consider shadows, I suggest that shadows are yet another place where a lot of color can occur. I often paint shadows with a cool mix of cobalt blue and opera or ultramarine blue and alizarin crimson. I find that shadows across green grass are best represented by a mixture of phthalo blue and burnt sienna. In addition, shadows add clarity and depth to a scene. They also suggest a time of day and can be used to create drama and mood.

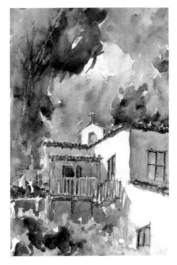

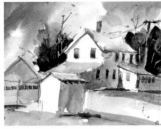

Shadows on White When painting white walls, I use the same color underpainting for both the walls in shadow and in the sky, integrating the elements for harmony. I use ultramarine blue and alizarin crimson for the wall shadows above and at left, using strong, diagonal lines for extra excitement. I make the shadow darkest next to the brightest wall.

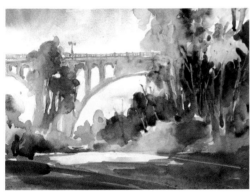

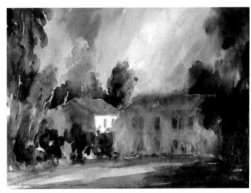

Foreground Shadows I like to exaggerate the length of the shadow along the ground, especially across the foreground. It suggests late afternoon, where all colors are saturated and the day is winding to a close. It also frames the subject and directs your eye upward. Remember to be consistent with the direction of light so all shadows come from the same place!

REFLECTIONS

Reflections are another great way to add energy and interest to a scene—and the best way to do this is through bright color accents. I favor juxtaposing complementary colors: a red person against a green tree or a golden-yellow person against a purple shadow. If I know I am going to include a reflection (say, after an afternoon rain storm), I paint it at the same time I paint the object. To suggest the flow of water or irregularity of puddles, I often make horizontal strokes through the reflection. In city night scenes and lakes, the reflection extends down farther than the height of the object. Remember: If the reflection is distinct, the water is calm. Rivers and busy water have broken bits of color.

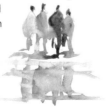

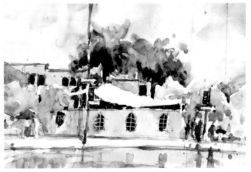

▲ **Street Reflections** Reflecting colorful cars and brightly dressed people on a rain soaked street looks great and keeps your painting loose and fresh.

◀ **People Reflections** For this, I used bright colors for the people and the reflections, painting them at the same time. Then, while the paint was still wet, I smeared it with horizontal strokes.

31

LESSON 1:
ARROYO BRIDGE

Although I believe strongly in painting outside whenever possible, it isn't always convenient to do so. Photography is a great tool that we can use to our benefit. On sketching excursions, I bring a digital camera—a small one no bigger than a cigarette pack that fits in my back pocket. I take a variety of pictures from all angles, striving for simplicity and good composition even in the early research stage.

Main Color Concepts

- Paint bright colors from a dull photo
- Create preparatory compositional studies (thumbnail sketches) to develop a strong value pattern
- Utilize a complementary color scheme

Breathing Life into a Reference This California bridge scene makes for a charming composition, but the colors are extremely dull. Remember that you are free take what you want from a reference and change the rest, as I do with the colors in this lesson!

Thumbnail Studies As I mentioned on page 19, I like to do a series of very small and very quick studies of the scene in order to understand the subject and why I want to paint it. I also want to break the scene into three or four basic value shapes and study the composition. If I can establish a good value pattern, it will serve as a road map for the final painting. I will refer to these tiny drawings throughout the painting process to keep me on track with my values. As you can see at right, I have explored a variety of different compositions. I like the one where the bridge is situated above the centerline. Notice how the trees on the right side of the frame balance the trees that are further out on the left side. Any medium will work for these study sketches; the most important part is to be simple and to establish distinctly different values.

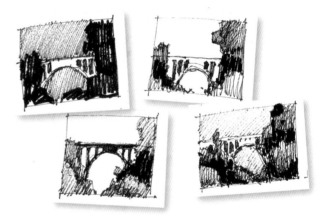

STAGE ONE

Sketch Drawing should be a pleasurable experience—not something to be endured or done quickly so you can get to painting. Take time to savor the experience. Listen to the pencil as it moves over the paper. Vary your grip. Make the line bold and expressive or light and delicate in response to your subject. A well-done drawing is a joy to paint, so perform this stage the best you can. I refer to my photograph and my value and composition studies as I design the framework for this painting. I use an HB pencil, as the graphite is easy to erase and won't score the surface of my paper.

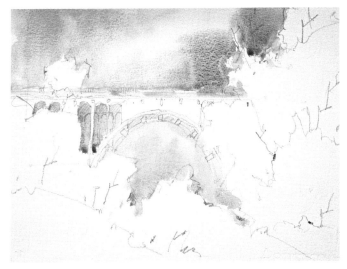

STAGE TWO

Sky I usually, but not always, paint the sky first. I like to start at the top of the painting and work down—plus the sky sets the tone for the painting and gets me enthusiastic to see how the elements will relate. Using a medium round brush, I start at the upper left with cobalt turquoise light and add raw sienna, cobalt blue, and ultramarine blue in a wet-on-dry wash across the sky, letting the colors blend and mingle. (I usually use three or four colors within a sky, sometimes adding yellows or reds, depending on my mood.) I paint the colors through and along the underside of the bridge, adding a touch of opera for warmth. This will be in shadow, and having the shadow color be the same as the sky wash will unify the painting. As I paint, I allow areas of white paper to show through to create a wonderful sense of luminosity.

STAGE THREE

First Wash of Trees In this stage, I deviate substantially from the reference. The photo indicates a calm array of green trees that are pretty much all the same color. No way! I take a big scoop of cadmium red light and lay it into the top tree shape, followed by generous helpings of new gamboge, greenish yellow, and a bit of permanent yellow-orange. I let these colors blend and mix on the page. When you get to this step, don't think, "I am painting trees." Rather think, "I am painting an abstract shape full of interesting colors in a medium value." And we aren't even using green yet! I do the same thing for the trees on the left, following my chosen value study as a roadmap.

STAGE FOUR

Second Wash of Trees Continuing with my medium round brush, I complete the yellow-orange bushes in the foreground using the wet-on-dry method. For the bushes in the lower right and the background tree, I mix green using phthalo blue and burnt sienna. This mixture creates a rich and unusual green and can be biased to the warm or cool side. (In this painting, I keep the mix biased to the cool side to suggest shadows.) I start with phthalo blue and add burnt sienna to the paper, letting the colors mix on the paper. I also add new gamboge to the foreground as I see fit.

STAGE FIVE

Define Trees with More Darks Using a medium round brush, I add a darker wash of color to the shadowed side of the trees and bushes, keeping in mind that my light source is coming from the right. I use pure cadmium red light, permanent yellow-orange, and new gamboge at the bottom of the tree mass and soften the color with water at the upper edge of the fresh paint. I use a darker mix of phthalo blue and burnt sienna for the green trees. I push the contrast as hard as I can, adding the deepest, darkest, purest mix of color to the lower regions of the trees and bushes. I leave the highlights unpainted, using the white of the paper to suggest glinting trees. I scrape out branch and trunk lines from the dark areas and paint dark branches with my rigger brush.

STAGE SIX

Bridge Shadows I rarely use black or gray for shadows—I like plenty of color in them. I usually use either alizarin crimson and ultramarine blue or cobalt blue and opera. Here I choose the more vibrant mix of cobalt blue and opera and apply it wet on dry. I start with blue at the top and add opera next to it, letting them blend on the paper. I paint just the shadowed archways and the large underside—not the sunlit front surface.

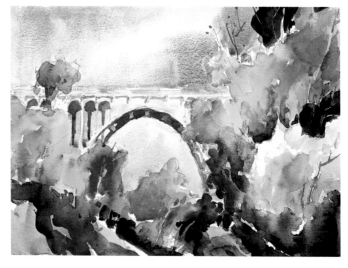

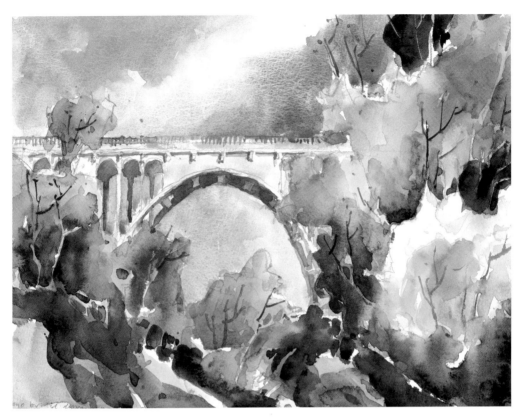

STAGE SEVEN

Final Darks and Details I go darker for the tree shadows now, using *negative painting* (painting around the actual object) to create tree trunk shapes. Using this technique in many places throughout the painting adds graphic interest and energy. I also scrape out a few branches to create the feel of thick, lush trees. Now I take my rigger brush loaded with titanium white and flick on more random branches. I also use my rigger to accent the architectural details of the bridge with ultramarine blue and alizarin crimson. I paint the railing and smear it with water in places to keep the entire flavor of the painting loose and informal. Finally, I negatively paint the railing using the blue of the sky; the railing is light in some areas and dark in others.

Details

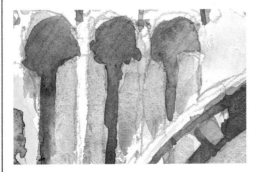

Bridge Shadows Even in a small, seemingly insignificant part of the painting, I let the paint mix on the paper. Cobalt blue and opera blend on the paper to create an interesting and colorful shadow.

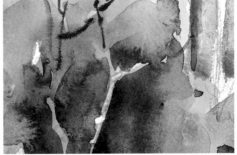

Trees and Branches These elements are most exciting when I use a combination of negative and positive painting. The branches above start out negative with the underpainting showing through. Near the top, I use a rigger and dark green to continue the branch.

LESSON 2:
ARCHITECTURAL LANDSCAPE

Nestled among the trees and flowers, the buildings in this reference are a small part of the entire composition but provide a crisp focal point that effectively contrasts with the larger, softer shapes of the landscape. I like how the red tones of the walls and roof relate nicely to the surrounding colors of the foliage. I make it a point to emphasize this color harmony in my watercolor painting.

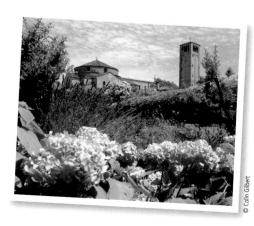

Main Color Concepts

- Incorporate architecture into a landscape using a harmonious color palette

- Express architecture with bold colors that relate to surrounding elements

▲ **Improving My Focal Point** This reference photo of the Basilica of Santa Maria Assunta in Torcello, Italy, was provided by a friend of mine. To make the photo work with my style of painting, I make a few changes in my sketch. I exaggerate the sizes of the roofs so I can use even more red, and I enlarge the windows so the building looks friendlier. I also lengthen the architectural elements ever so slightly and eliminate a few unnecessary planes for simplicity's sake.

STAGE ONE

Drawing and Sky A nicely done drawing is an inspiration to paint, so I create my sketch very carefully, paying closest attention to the perspective of the buildings. I suggest only the basic forms for the trees and flowers, keeping the focus on the church. Then I use a medium round brush and all of my blues to paint a washy sky. I start with cobalt blue at left, blend in cerulean blue toward the middle, and end with ultramarine blue and a touch of opera at right. You can do it the other way around—the point is to vary the color and the intensity to create an interesting, multi-colored sky. (And don't forget to let some white paper show through.) As I paint, I pull the blue washes into the building shadows, harmonizing the building with the sky and creating unity within the piece.

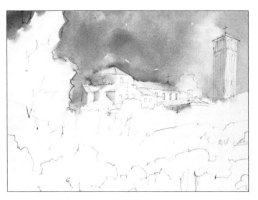

STAGE TWO

Trees Beginning again on the left, I paint the large tree using a variegated wash with a mixture of phthalo blue, burnt sienna, greenish yellow, and new gamboge, letting the colors blend together on the paper and leaving some slender tree trunk shapes unpainted. I use the same colors to build the trees across the middle of the painting and behind the church. Note how there are no specific tree shapes but rather single shapes of blended color—bright yellow at the top and deep blue-green at the bottom. As the paint starts to dry, I scrape out trunk shapes in a random pattern, varying them in size, shape, angle, and position. Now I stroke new gamboge and greenish yellow over the foreground at left, leaving a tiny edge of white paper along the top. The contrast between this yellow and the dark tree above will make the foreground appear to glow in the sunlight.

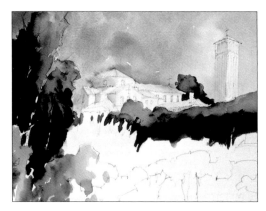

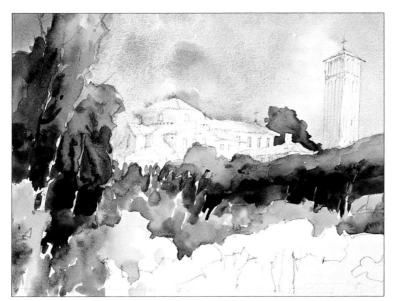

STAGE THREE

Background Flowers
Although the reference photo identifies many distinct flowers, I treat them as an expression of vibrant color and interesting shapes. Using a medium round brush, I paint the flower area starting with opera at the left, mixing in mineral violet as I move across, moving to pure new gamboge, and then ending with a touch of opera and greenish yellow. I also add new gamboge and greenish yellow—you can even throw in olive green. The colors blend together but remain distinct. When you do this, don't dab the paint or you'll end up with a confusing mess of unrelated colors and shapes.

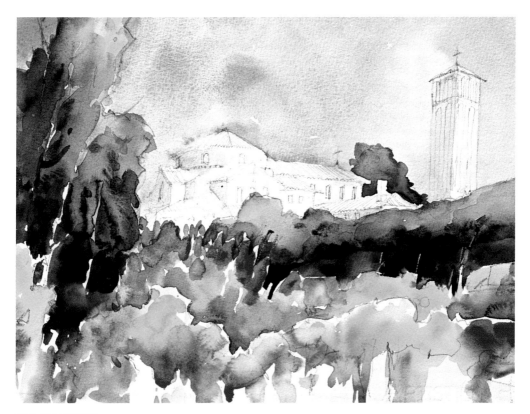

STAGE FOUR

Foreground Flowers I use the same technique to add the foreground flowers, moving from left to right and blending as I go. This time I start with cadmium red and progress to permanent yellow-orange mixed with new gamboge, leaving a slight white edge between the foreground and background flowers. I add a few touches of opera within the foreground flowers to tie the composition together. Then I pull some of the color straight down to suggest stems, leaving white areas to fill in later.

STAGE FIVE

Foreground Shadows and Church After the foreground flowers dry, I add dark, cool greens beneath them using phthalo blue, burnt sienna, and a touch of new gamboge for fun, leaving the stems showing through for an interesting, random pattern. I vary the green tones to create interest even in this low-key, subtle area. Next I move on to the church, adding a very light wash of cadmium red light over the roofs. I also add touches of new gamboge where the sun reflects off the tiles. I aim for an overall wash of bright, warm colors for the church. The initial blue areas show through, suggesting the effect of cool shadows on a warm building.

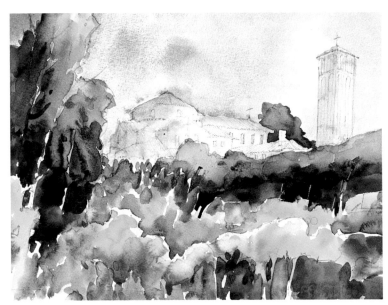

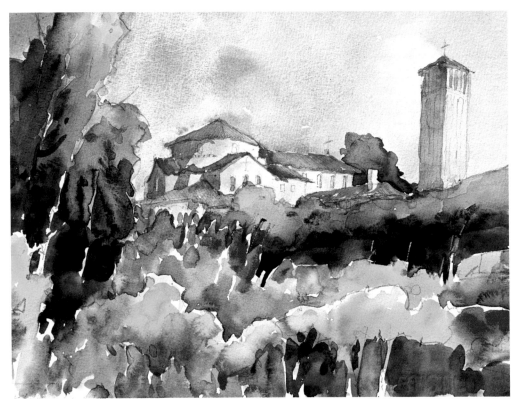

STAGE SIX

Church Shadows and Roofs Once the wash over the church dries, I add depth to the shadows using a mixture of opera and cobalt blue. This electric color adds vibrancy to the shadows; the more the paint is allowed to mix on the paper, the more energy it will have. Now I use a small round brush to apply another wash of cadmium red light to the tile roofs. I'm careful not to make the wash flat, varying it with hints of yellow so it has depth and volume. The loose analogous color scheme of the building (warm reds through purples) creates harmony within the architectural elements but effectively sets off the building from the surrounding vegetation.

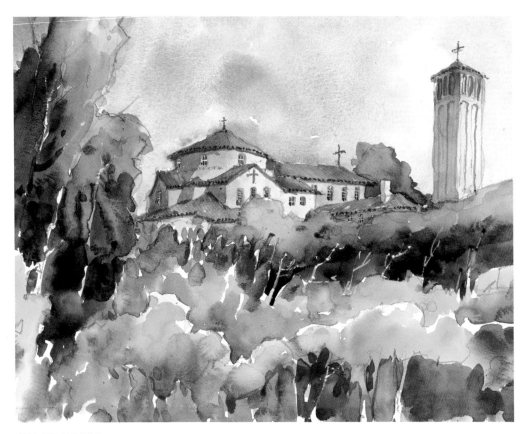

STAGE SEVEN

Final Details Using the tip of my rigger brush, I fill in the windows with a wash of cobalt blue and phthalo blue mixed with new gamboge. Although the windows are tiny, a mix of colors will suggest the reflections of sky and trees. I add purple to the arches in the tower and dark accents to the underside of the roofline and along the grooves of the tower. The addition of these calligraphic strokes adds articulation to the architecture, drawing the viewer's eye to the focal point with detail. Using my rigger brush, I add the crosses to the rooftops with ultramarine blue. Finally, I use titanium white to paint the window mullions and add a few branches in the dark areas of the trees.

Watercolor relies on the white of the paper and the translucency of the paint to create light,
so it's wise to go easy on the paint—especially in the early stages.

LESSON 3: DOWNTOWN URBAN LANDSCAPE

I took the reference photo for this demonstration with my small digital camera while driving home from the airport. The beauty of downtown Los Angeles struck me; I love its variety of building styles, colors, and graphic themes. It is like a giant still life accented with deep green trees and tall palms waving in the afternoon sun, set against a backdrop of purple mountains. To top it off, an airplane passed overhead on its final approach into LAX. My goal for this exercise is to capture the bustling, energetic feel of the city using a colorful medley of bold paints and expressive linework.

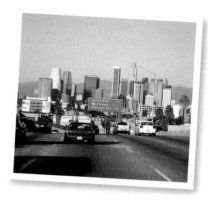

Main Color Concepts

- Render a monochromatic urban landscape with bold and unusual colors to create excitement and energy

- Use pen and ink to create an underlying form and structure that will liberate the expression of color

- Use linear perspective in combination with color to suggest depth and distance

▲ **Balancing the Photo** The composition of my reference photo needs some adjustment to make a better painting. First, the sign is right in the middle of the scene, capturing all the attention; also, the red car is right below it. While exciting, the close proximity of these complementary colors will take away from the balance of the scene, so I move the sign to the right and make it smaller. I also enlarge the primary subject (the downtown cityscape) and reduce the size of the freeway.

STAGE ONE

Contour Drawing Instead of doing a series of thumbnail sketches, I start right off with the final drawing, using a permanent sketch pen and hot-press watercolor paper. A contour drawing works best for this situation. For this type of drawing, the pen moves from object to object in a freeform style without much attention to detail, addressing mainly outlines and plane changes. What I can't see I make up. I scribble in windows with bold strokes; some are horizontal and some are vertical, dictated only by whim and what looks interesting. I'm sure to leave some areas open (white space) so there is a sense of balance throughout. You'll find this method of drawing to be quite liberating.

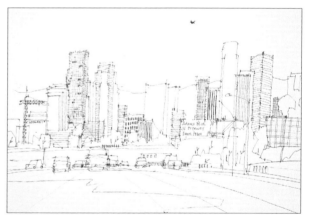

STAGE TWO

Sky, Mountains, and Shadows The sky will need plenty of color to work with the bright buildings, so I apply a wet-on-dry wash of cobalt blue, cerulean blue, ultramarine blue, raw sienna, alizarin crimson, and opera (yes, opera!). The non-blue colors add vibrancy and a sense of electricity. I use a medium round brush and a light touch; it is easy to overdo it and lose the feeling of bright luminosity. After applying paint to the paper, I readdress areas of the sky with pure water, letting the colors run, bleed, and mix together. Then I lay in the background mountains and the foreground shadows with cobalt blue and opera (mixed on the paper—not in my palette!). Using the same colors as the sky will tie the painting together from the very beginning and create visual harmony.

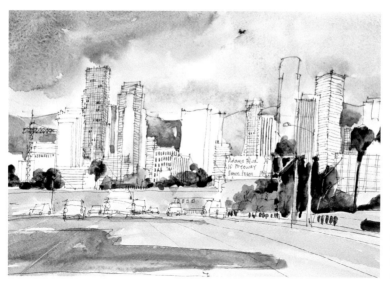

STAGE THREE

Warmth and Contrast
I suggest the warmth of late afternoon with a glaze of raw sienna in the foreground, following the perspective lines of the freeway. I bring this color into a few buildings and the wall shape in the middle of the painting, which relates to the touch of raw sienna in the sky. Now I punch up the light areas by using a medium round brush to throw in some dark trees with a mix of phthalo blue and burnt sienna. While this is still wet, I add new gamboge to the upper parts of the trees, letting the color run down and mix with the darks. When the paint dries a bit, I scrape out tree trunks.

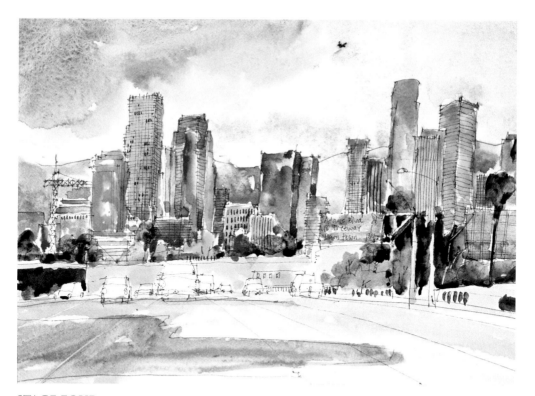

STAGE FOUR

Buildings I paint very boldly in this stage—complementary colors abound! (Don't look at the photo reference or you will lose your nerve.) I use my brightest colors (I mean bright!) to paint the buildings, beginning with the cluster of buildings at left. I use cobalt turquoise light, permanent yellow-orange, greenish yellow, opera, cadmium red light—I use them all! I mix on the paper (of course), combining different colors on each building: cerulean blue with new gamboge, ultramarine blue with alizarin crimson, greenish yellow with phthalo blue—you get the point.

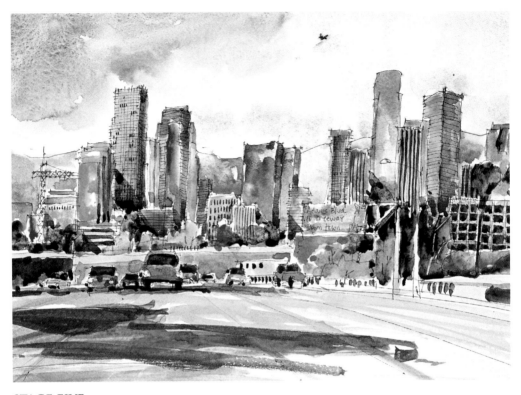

STAGE FIVE

Buildings and Cars Using the same spirit (and colors), I paint the cars. Think Disneyland's Autopia. The brighter the better! Now I add depth and dimension to the color explosion; after all, I am painting a scene of buildings, not just colors and shapes. The time of day (late afternoon) means that shadows will be getting long and dramatic. (I already painted one across the foreground.) I am going to create two kinds of shadows now. The light source is coming from the left, so I paint a glaze of cobalt blue (as I did in the sky) on the right sides of all the buildings. I use a small round brush and a light touch so the building color shows through. (This is why transparent watercolor is so much fun.) The second kind of shadow is a cast shadow. On selected buildings (mostly the ones behind other buildings), I paint an angled shadow line from the upper left to lower right, using a darker transparent glaze of blues: cobalt, ultramarine blue, and phthalo blue. I vary and mix the colors, making sure the shadow angles are consistent.

Details

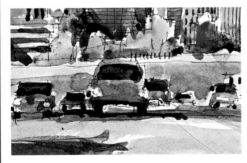

Highlights Selective use of white (unpainted paper) adds sparkle to the painting by suggesting bright sunlight, especially when surrounded by dark shadows.

Fine Details I use my scraping tool to suggest tree branches, window mullions, and architectural details. I paint windows with a dark color, leaving the frames unpainted.

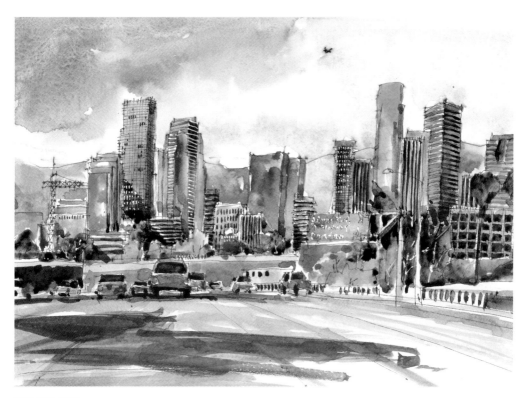

STAGE SIX

Final Details It's time for the final touches. Using my rigger brush and titanium white or ultramarine blue (depending on what best suits the building color), I draw horizontal and vertical lines on different buildings, create grids of window patterns, and add little graphic dots and shapes to suggest the details of city life. Finally, I apply titanium white to the windows in the shadow areas and on the sign. This adds the last bit of spark. Now I'm finished!

Details

Freeway Sign Signs add a touch of pure urbanism to a city scene. I wrote this lettering with pen during the initial drawing stage. At the end, I add some highlights to the copy with titanium white in a somewhat random fashion.

Building Elements You can see there is no real painted detail here—just lines, shapes, and values. Notice that where the shadow falls across the building, I highlight the windows with small strokes of titanium white.

LESSON 4:
MOUNTAIN LANDSCAPE

For this gorgeous landscape, I choose to let the natural, vibrant colors sing by simplifying the scene into large shapes. This is a fairly straightforward drawing exercise. In my sketch, I keep the shapes big and simple, and I refrain from drawing any detail. I keep the lower-left foreground marsh grass much more basic than the photo, and I enlarge the tree and bush on the right.

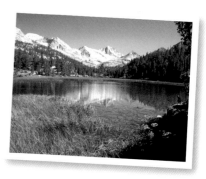

Main Color Concepts

• Use complementary colors to create vibrancy

• Suggest distance and atmosphere through color temperature

• Mix greens using other colors

▲ **Finding the Perfect Spot** I captured this scene on a hike in the Sierras with a good friend. Distant snow-covered mountains surround a placid lake bordered by luminescent aspen trees and dark evergreens. In the foreground, sunlight glints off a golden tree perched precariously atop a shadowed, rocky ledge. It will be a challenge to do this justice!

STAGE ONE

Sky, Shadows, and Reflections Using a medium round brush and the wet-on-dry technique, I begin with cobalt turquoise light in the sky at left, adding cobalt blue, ultramarine blue, and mineral violet as I move to the right. I pull the mixture down into the shadows of the mountains, leaving no edge or line in between. I use the same mixture for the distant mountains at right. While this is fresh in my mind, I paint the lake reflection. It will be a mirror image of the sky, at least for now. I try to copy exactly what I did in the sky, using the same colors, blending, and mountain shadows.

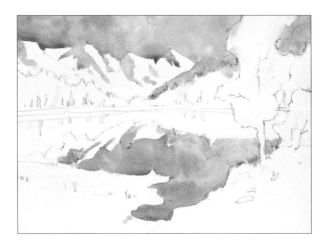

STAGE TWO

Distant Trees Now I use a small round brush loaded with phthalo blue and burnt sienna to paint the tree mass at the far left edge, adding new gamboge in areas as I move right. I leave some white paper in small vertical shapes to suggest tree silhouettes. Continuing the wash as I move to the right, I add more phthalo blue and a little ultramarine blue. These trees are in shadow and need to appear cooler and darker. Now I create the reflection of the trees by repeating the same process in the water, creating a mirror image. Beginning with my green mixture on the left, I add bright yellow as I move to the right and finish off with deep blue-green.

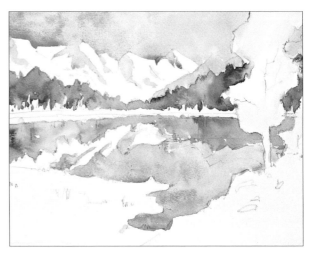

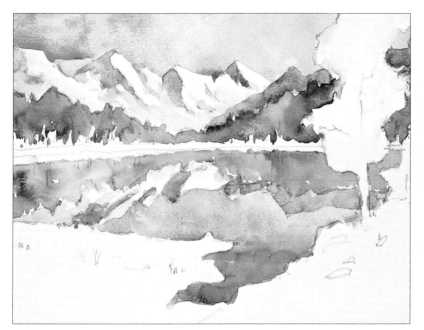

STAGE THREE

Deeper Washes To punch up the distant mountains, I add a bit of alizarin crimson to the shadows and their reflections at left, and I add ultramarine blue to the mountain reflection at right. I also add phthalo blue along the bottom of the lake reflection to give a sense of depth.

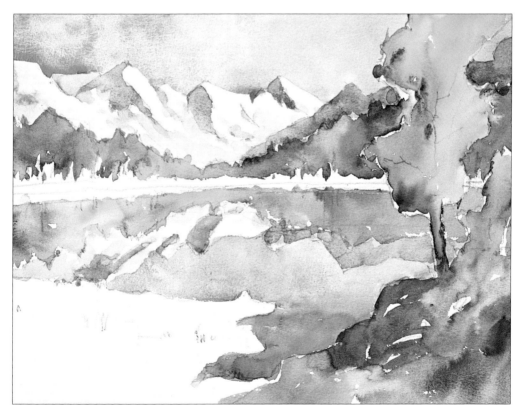

STAGE FOUR

Foreground I move on to the foreground and paint the top of the tree with new gamboge, adding greenish yellow and olive green as I move down. I also throw in burnt sienna for texture. Then I paint the small bush in the same manner, letting the color bleed down into the cool shadows of the rock, which I add with ultramarine blue and burnt umber. At the bottom of the rock pile, I lighten up the wash with olive green.

STAGE FIVE

Marsh Grass I want this area to be brightly lit by the sun, creating a warm foreground that will push the cooler background elements farther into the distance. Using a medium round brush, I lay in a wash of new gamboge, then mix in a little greenish yellow and olive green. I let some white paper show through so the area glows with sunlight.

At the bottom, I add permanent yellow-orange. This frames the foreground and lightly balances the dark values of the right side. The yellow marsh grass will accent the complementary purple shadow.

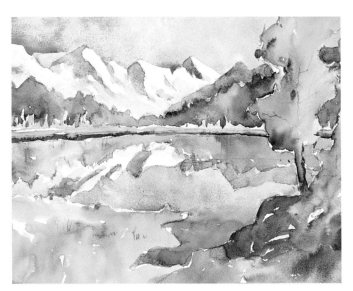

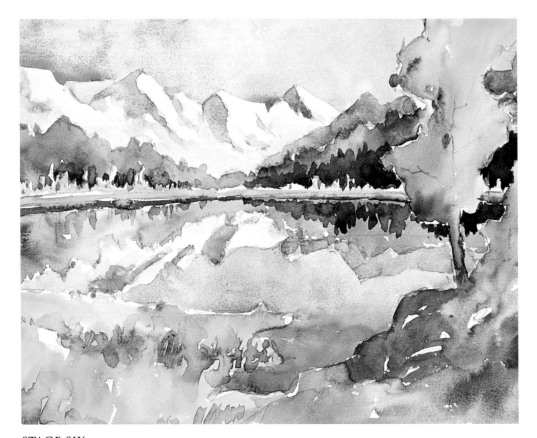

STAGE SIX

Darkest Darks Using the small brush, I paint the dark evergreens surrounding the lake with a mixture of phthalo blue and burnt sienna. Because the left side is in sunlight, I use restraint while painting it; I use the darks only to accentuate the bright yellow aspens. On the right side, I lay in darks more heavily, changing the proportion of blue and sienna for variety. Whatever I do on the shore I copy in the lake reflection. Using olive green, I add darks to the foreground marsh grass and, as it dries, scrape out a few blades with my scraping tool.

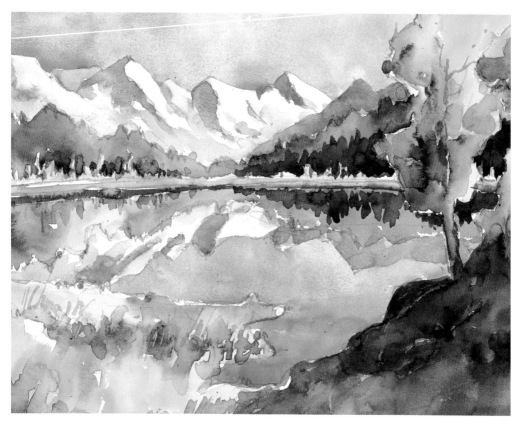

STAGE SEVEN

Final Details I begin this final stage by adding more darks to the foreground tree and bush using phthalo blue and burnt umber. Where the tree meets the rocky outcropping, I add ultramarine blue and use less water so the color is rich and dark. Then I drop in a bit of alizarin crimson and burnt sienna to suggest colorful rocks. Next I add some splashes of cadmium red here and there, but not everywhere. It's important to be selective—I limit myself to the trees around the lake and a few touches in the foreground rocks.

Details

Distant Trees Notice how vaguely I render the trees and reflections. The three dots of complementary red beneath the trees could suggest a number of things—people, cabins, whatever the viewer chooses.

Foreground Tree The warm yellow-green trees complement the blue-violet sky and mountains. I indicate branches using a rigger brush and a mid-value olive green.

LESSON 5: SUNSET

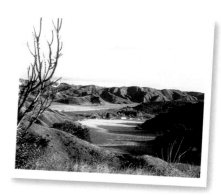

As you can see by looking at the photograph, it was a challenge to bring this subject to life. Plagued with dull color and a lifeless sky, the scene looks like something from *The Streets of Laredo*—all that's missing is a longhorn skull in the foreground and some vultures flying overhead. However, there is something alluring about the way these layered mountains frame the valley of shadows. With a few adjustments in mind, I see plenty of potential in this composition, making it a perfect reference for exploring how to get an expressive painting from a seemingly desolate landscape.

▲ **Deciding My Course** Although there are several ways to approach this situation, I choose to add interest primarily by changing the time of day. I see this scene as the perfect location for a dramatic sunset, which will give life to the plain sky and warmth to the colors of the land. A warm color palette full of rich greens is just what I need to turn this reference into a lush, fertile farm scene.

Main Color Concepts

- Make a colorful painting from a plain photograph

- Use a multi-colored underwash to unify a painting

- Change the time of day to add drama and alter mood

- Use both complementary and analogous color schemes

STAGE ONE

Sketch I leave the composition pretty much as is: a valley surrounded by mountains with some trees in the foreground. However, I decide to fill out the trees in the foreground so I can later enrich this area with vibrant color and softer shapes. I also add furrows in the valley to give a sense of perspective and draw in the viewer's eye. As I draw on the watercolor paper, I vary the line weight, allowing the pencil to respond appropriately to the contours of the elements. I don't add too much detail, as this can wait until the final stages.

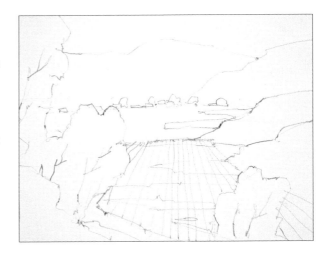

STAGE TWO

Underwash Using a large round brush, I apply a wash of new gamboge in the upper right, gradating to permanent yellow-orange, alizarin crimson, ultramarine blue, cobalt blue, and olive green—almost the entire color spectrum! I paint loosely, remembering to use a light touch and enough water to keep the paint clean and fresh. I aim for a smooth transition from color to color, which will create a sense of unity among the elements in the final painting.

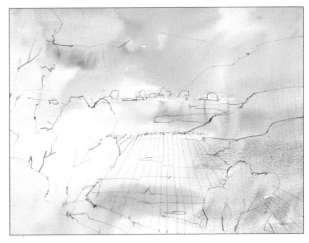

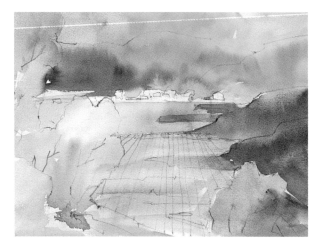

STAGE THREE

Sky and Mountains What initially seemed like an intense wash of color in stage two has faded a bit, so I punch up the sky using the same colors as in the underwash. To add the distant mountains, I apply permanent yellow-orange with a large round brush, adding alizarin crimson as I move left and allowing the paint to mix on the paper. For the hills at right, I lay in a mix of alizarin crimson and mineral violet, adding cobalt blue and ultramarine blue as I work down the paper. I pull these colors into the field to suggest shadows. Now I cover the trees and field with a wash of olive green, greenish gold, and new gamboge, which will give a warm glow to these areas, even through subsequent layers of paint. I play with the color intensity and amount of water in this wash so there are plenty of light areas showing through.

STAGE FOUR

Darkest Darks Now I add the darkest darks. With a medium round brush, I use phthalo blue and burnt sienna to paint the middle areas of the trees, stroking around the shapes of the trunks. While this is still wet, I add greenish yellow and new gamboge to the tops of the trees and let the paint run down to the darker green. I paint the trees on the right in the same manner, connecting the two masses of foliage with streaks of dark shadow along the foreground. These dark, framing trees accentuate the brightness of the field.

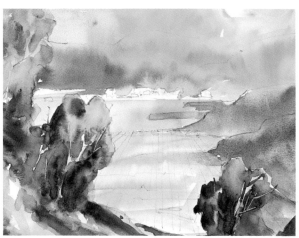

STAGE FIVE

Mountain Definition To show depth and dimension, I need to refine the distant mountains a bit. I add a light wash of cadmium red light mixed with a bit of permanent yellow-orange over the top edge of the mountains directly under the sun, subtly defining the mountain ridge. Then I paint a third hill on the right side of the scene using cadmium red light and alizarin crimson. To add depth to the purple hills, I further define the contours with mineral violet and ultramarine blue, leaving a fine line unpainted between the overlapping hills, which allows the unifying underwash to show through.

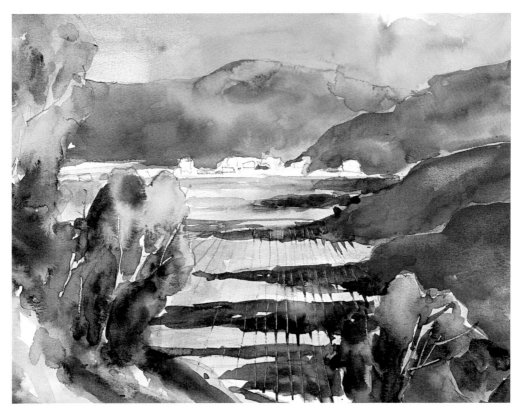

STAGE SIX

Shadows In this Golden Hour (an artist's term for late afternoon when colors are rich and saturated) painting, the sun is setting and casts long, dramatic shadows across the field. Adding these shadows does a few things: it suggests the time of day—a cool, early evening when the day's work is done—and it provides an interesting compositional element. Before tackling the shadows, I paint a wash of greenish yellow and new gamboge over the field with a small round brush. This will brighten the field and give it depth. Continuing with a small round brush, I mix phthalo blue and burnt sienna and paint horizontal shadow shapes going across the field. I make them random rather than regular and even. Then I paint a thin, horizontal shadow in the far field using olive green mixed with a little cobalt blue. The far field shadow should be lighter and less intense to suggest distance. As the shadows dry, I scrape out some furrow lines, moving toward the distant hills in one-point perspective (see the diagram on page 21). Using a rigger brush and olive green, I paint the rest of the furrows, aligning them with the scraped-out furrow lines. Next I darken the furrows in the shadow areas using phthalo blue.

Details

Furrow Lines Using my scraping tool, I scratch through the dark green shadow color. This creates light lines in the dark areas and dark lines in the light areas.

Trees and Distant Hills Here the opera-colored distant hills accent the yellow-green tree colors by means of a split-complementary color scheme.

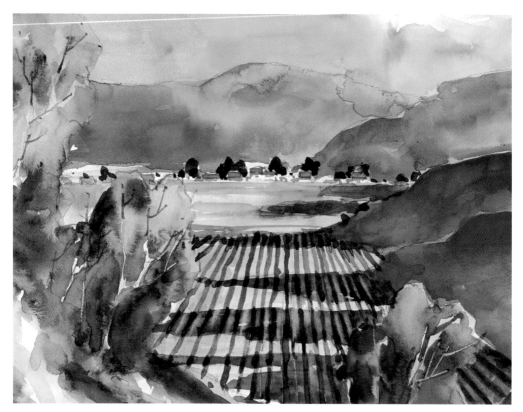

STAGE SEVEN

Distant Farm and Final Details A farmer goes home for dinner after a hard day's work, so I have to complete the sunset story by including a farmhouse and a barn. Using cadmium red and a small round brush, I paint the roofs, slightly varying the sizes, heights, and shapes to suggest different buildings. When dry, I add dark tree shapes behind the buildings, which makes the red roofs pop. Now for the most exciting part: I use cobalt blue to paint a small line of shadow under each red roof. I add a few random shapes over the buildings using this color, but I keep my strokes subtle. Believe me, the smallest details will show up and give your painting depth and clarity.

Detail

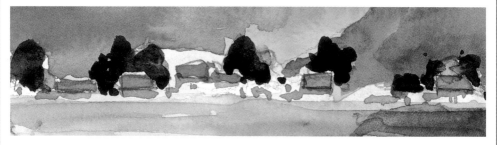

Farm Buildings This is an actual-size portion of the painting, which allows you to see how loose and free from detail I remain when addressing the farm. Simple shapes and colors convince the viewer of a series of small buildings and trees in the distance.

LESSON 6: NIGHT SCENE

The general idea for this method of painting a night scene came from a demonstration by fellow artist and friend Tom Lynch. He painted an interior church scene with a strong light source at the top (coming through stained glass windows) that faded to low light at the bottom. One day I received a commission to paint a city scene at night, so—not really knowing where to start—I drew on my memory of Tom's demonstration.

When you paint a night scene, think of it as though you're painting light in fluid form. It is brightest at the light source and gets darker as you move away. The best way to understand this and really see it is to take some photos at night. The first part is easy; just go outside after dinner and look for a good light source with plenty of people, cars, trees, buildings, and action nearby. The second part—capturing it on film or digitally—is the hard part. The camera will probably need a one- or two-second exposure. (If you're working digitally, your camera will most likely have a night setting.) I recommend that you set your camera on self-timer mode and use a tripod (so your hand won't jiggle the camera). Be sure the flash is turned off, as this will remove all dramatic light. If you follow these steps, your camera will capture the gradations of bright light to deep dark. Now it's time to capture it on paper with watercolor!

▲ **Thumbnails** A thumbnail sketch will help you begin to understand the focal point of light and the concept of glazing color over the entire paper to paint light. Before beginning to paint the objects in the light, I sketch the basic linework of my subject (a gathering of patrons going to an evening concert). Next I create a series of gradating pen scribbles right over my drawing, moving from light to dark and keeping the center (the light source) bright white. Already you can see how bright the light is. You may want to create a small color study next, just to get more practice visualizing light and laying down a gradated glazing wash.

Main Color Concepts

- Paint the fluid qualities of light with a loose analogous color scheme
- Create a center of interest with cool darks surrounding a warm, light focal point
- Vary the time of day and your usual color palette
- Use cool colors to create a nighttime feel

STAGE ONE

Sketch and Frisket I draw my scene with medium-weight pencil lines (you can use waterproof pen, if you prefer). I am expressive with my linework and have fun, even though it is "just" the drawing. Now I move on to preserving the white of the paper. Because this night scene involves dark washes, I have to decide which areas to keep free of color right from the start. I determine that the lower part of the building and the walkway will be the brightest areas. This glow will serve as the center of interest—I won't be putting much paint here. However, there are other spots in the darker areas that I want to be white, including the windows on the building and the car headlights. I apply liquid frisket to these areas. (See "Using Liquid Frisket" on page 54.) Of course, I could use white paint, but this wouldn't be nearly as much fun—plus the white of the paper produces a brighter and more exciting glow. I let the frisket dry before proceeding, and I clean my brush.

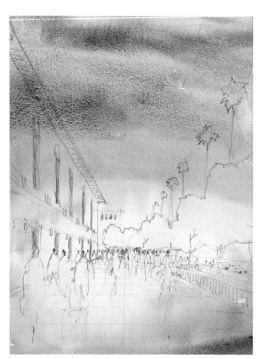

◄ STAGE TWO

First Washes Starting in the center (the illuminated area), I lay in clear water with my brush in a circular motion, moving from the center outward. I leave the very center unpainted—I want the paper to show through here. I add new gamboge and a little raw sienna, continuing to work in a circular pattern. Now I add alizarin crimson, which gradually bleeds into ultramarine blue. I now have a circular spectrum of color with white paper at the center, fading to red and purple and ending in blue at the edges. (You will probably apply at least four washes in this stage, although the exact number depends on the strength of your washes.)

► STAGE THREE

Darker Glazes Once the first glaze dries, I repeat the process using more color, keeping the center unpainted and increasing the value as I move outward. I do this again and again until I see a bright glow of light in the center and deep, rich darks along the edges. Then I darken the sky with a wash of burnt umber and phthalo blue.

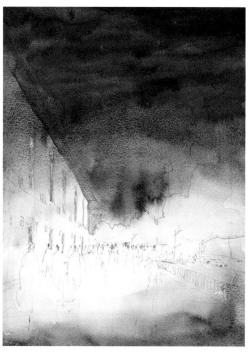

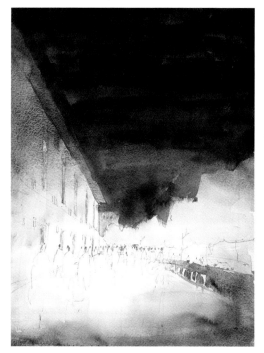

◄ STAGE FOUR

Trees and Foliage Once I am satisfied with the richness of the sky, I address the railing on the right, adding water as I move toward the center of light. I merely suggest the forms; remember, the goal is to create a mood, not a rendering. Now I work on the trees, painting them in the opposite manner as I would in daytime. Because the light is coming from below, the lightest green is there (gamboge plus phthalo blue), and the darker green (made from phthalo blue and burnt sienna) is at the top of the tree. As before, the closer objects are to the center of the light, the brighter they will appear.

STAGE FIVE

People and Reflections In this stage, I add suggestions of people. (What would a concert be without the audience? Pretty lonely!) I want to trick the viewer into thinking that these colorful blobs of paint are the patrons. Using the point and shoulder (the fattest section) of the brush, I follow my sketch to lay in a variety of shapes and sizes, adding small dots for the heads. I use a large brush and forget the detail. This concert is on a summer evening, right after a brief rain has sparkled things up. To suggest this, I add reflections that follow the size and shape of each blob, using a more diluted version of each blob's actual color. Then I smear the wet paint around a bit to make it messy and interesting.

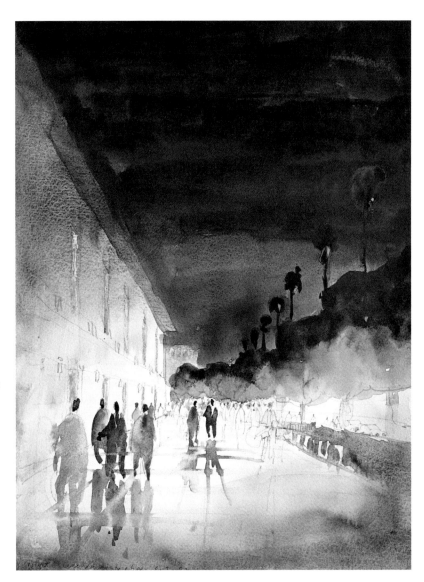

Using Liquid Frisket

Many watercolorists use liquid frisket, or masking fluid, which is a latex-based substance that temporarily protects specific areas of a painting to keep them from being covered by paint. Be sure to use a brush you no longer want because the frisket will ruin the bristles and make it unusable for sensitive painting. I use an old, small round brush that I have marked with a red pen. I apply dish detergent to the brush before dipping it into the frisket to make cleaning the brush much easier. Simply stroke on the frisket like paint (A); when dry, the frisket repels paint, so you can apply colored washes over it without affecting the paper (B). When your painting is complete and dry, gently rub off the frisket with an eraser (I prefer kneaded) to reveal areas of pure white (C).

A

B

C

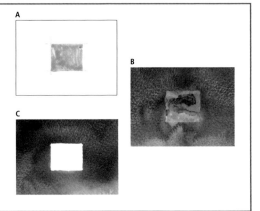

54

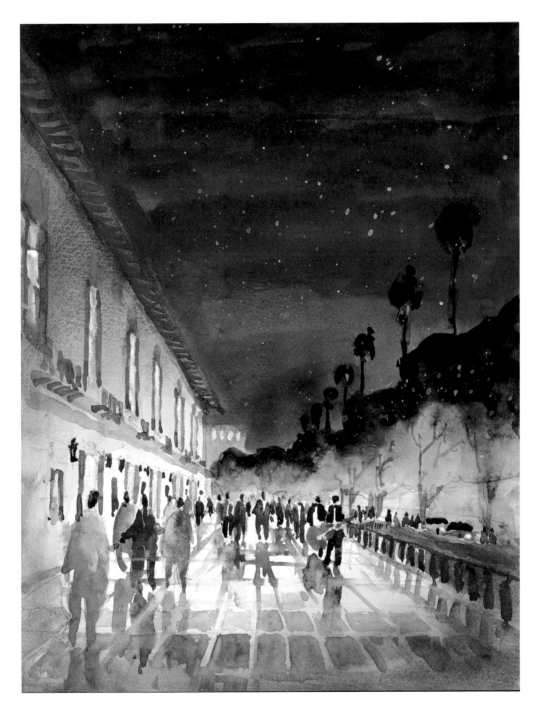

STAGE SEVEN

Final Touches Using either a fine-pointed brush or a rigger (or both), I paint suggestions of details throughout the scene: tree branches, light fixtures on the building, people in the distance, architectural elements, seams in the walkway, and so on. A little detail in selective areas will go a long way and convince the viewer that there is more detail than there actually is. (On the other hand, too much detail will lessen the impact of an impressionistic painting.) Once the painting is dry, I use a kneaded eraser to carefully remove the frisket from the paper. The brilliant brightness of light shows through, especially where it's surrounded by darker colors. Sometimes, as in this case, I will still accent the windows and other light areas with white. Then I use a light gradated wash of new gamboge to give a warm tone to the light. I also paint mullions and frames in the window areas. To finish, I splatter white paint in the sky for raindrops, tapping the handle of the loaded brush to create expressive drops.

LESSON 7: FRUIT & WINE

For this still life painting, I take the opportunity to draw and paint from real life. It's my favorite way to paint because instead of interpreting a two dimensional image (a photo), I can see my subject in three dimensions. This allows me to be more selective and expressive in what I want to show.

In this simple still life, I positioned the elements in a sparse composition rather than a traditional clustered setup. I find this more interesting because the objects command the entire frame of the scene, with plenty of negative space throughout. I also prefer to have elements break out of the frame whenever possible. To determine my composition, I often use a cropping square (a small piece of cardboard with a rectangle cut out of the center).

Main Color Concepts

- Paint reflected color and light
- Let colors bleed to create lost and found edges
- Let the white of the paper show through to create highlights
- Use bold colors in your shadows

▲ **Setting Up** I place the still life elements randomly on my worktable, not worrying about the surface or the lighting situation. This photo shows my setup (although I paint it from a slightly different angle). You can follow this lesson or set up a scene of your own. Any items will work. Charles Reid (one of my art heroes) sets up beautiful still life scenes using common items from his kitchen: silverware, plates, cups, vases . . . anything and everything.

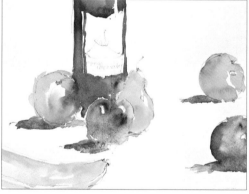

STAGE ONE

Drawing Even with this real-life subject in front of me, I take some liberties with the arrangement of the objects. In fact, I move things around as I draw to make sure the composition is to my liking. I try to make the drawing as expressive as possible, varying the line weight and feel of the strokes. Sometimes I draw the shadow side of the object using a heavier line and even fade out the highlight side entirely.

STAGE TWO

Initial Wash It looks like I paint the whole scene in this first stage, but it is really just one extended wash. I use a medium round brush and a mix of phthalo blue with a touch of burnt sienna for the wine bottle, leaving the label and highlights white. I explore the concept of "lost and found edges"; I make the wine bottle and fruit blend together in places and distinct in others, creating loose, impressionistic passages. The eye will complete the form where the paint does not. I move on to the apple using cadmium red, adding new gamboge for depth and volume and cobalt blue for the cast shadow. Some of the fruit color seeps into the shadow color, suggesting reflected light. I continue with the rest of the fruit, switching to new gamboge for the banana, permanent yellow-orange for the orange (big surprise!), and new gamboge for the pear.

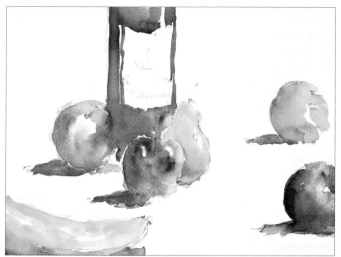

STAGE THREE

Bold Shadows I add more volume to the fruit now by shading the left sides. Instead of using a strict complementary color (like the masters do), I prefer to freelance the shadow color with a mixture of bold shades, some from a complementary range and some not. The orange fruit takes cobalt blue and a little cadmium red; the yellow fruit takes permanent yellow-orange, cadmium red, and a touch of burnt sienna; and the red fruit takes alizarin crimson and ultramarine blue. I don't worry about being accurate here—I just splash bold colors on the dark sides of the objects, being sure to leave the white paper for the highlights.

STAGE FOUR

The Label This step is pretty straight-forward—no tricks, I promise. The wine bottle I selected for this exercise has a nice, colorful label, and even so, I exaggerate it somewhat. Using a small round brush, I paint the top corner with a mixture of cerulean and cobalt blue, leaving a slight white line to denote the edge of the label and to make sure it stands out from the dark green bottle. Next I paint the rest of the label using pure colors right from the tube. I let the colors bleed together only occasionally; there should be a distinction between the colored shapes, following the label design. I continue the vertical highlighted reflection line on the bottle through the label. I will add the lettering later with white paint.

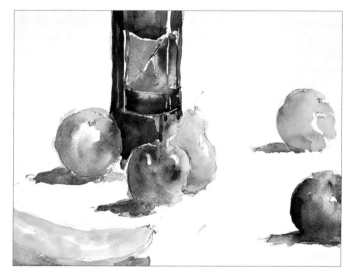

STAGE FIVE

First Background Wash The background will be an abstract wash of bright colors. It shouldn't distract attention from the subject. I have seen many still life scenes ruined by an over-painted, too-detailed rendering of cloth. My advice? Keep it simple. Using my medium round brush, I paint an overall wash of blended colors throughout the entire background. I like to use complementary colors whenever possible so the subject pops out from the background and vibrates. I use a generous amount of water and tilt my paper so the colors bleed and blend uncontrollably. The more accidents, the better.

STAGE SIX

Deeper Background Washes Remember that watercolor dries much lighter than it looks on application, so if you don't like something, let it dry before you worry about it. It will probably look just fine in a few minutes. However, I notice that my initial wash has dried a little too light, so I come in again with more color. Notice how the transparency of the watercolor gives dimension to the painting.

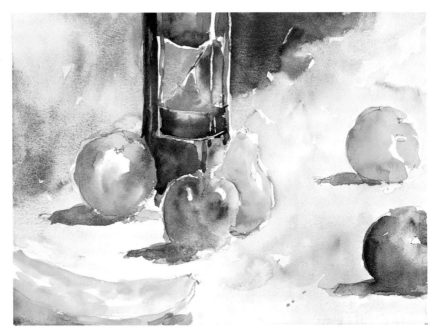

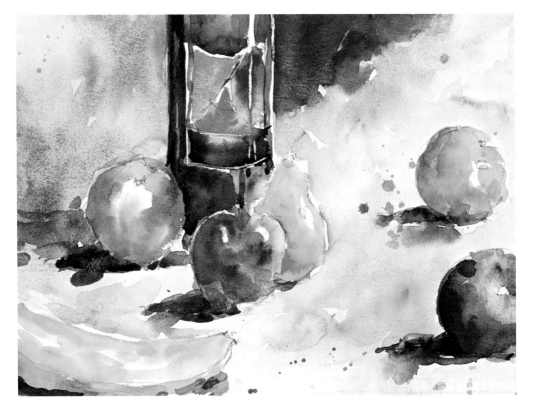

STAGE SEVEN

Shadows and Splatter I use washes of mineral violet, opera, ultramarine blue, and alizarin crimson to warm up the background in some of the darker areas. I punch up the shadow colors with cobalt blue and splash the painting with random colors and clear water.

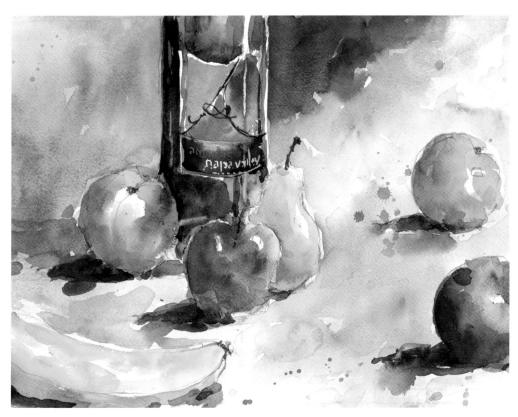

STAGE EIGHT

Lettering and Final Touches Now for the finish. I use my rigger brush and a mixture of ultramarine blue and burnt umber to add stems and other dark accents to the fruit. I keep it loose and touch the areas with clear water after I paint them so they smear around a little. I add a few dark strokes to the label to suggest lettering and other graphics. Using clear water, I paint a curved line where the far side of the bottle can be seen; then I dab it with a tissue to remove the paint. Finally, I paint the large lettering on the label with titanium white.

> *The most important thing is to let some small areas of white paper show through where*
> *the light reflects off the fruit. This will make your painting glow with brightness.*

LESSON 8: SPRINGTIME

For this lesson, you can work from my photo, or you can set up your own flower still life. I suggest the latter because you can see everything in three dimensions, and the flowers smell great! For this setup, I bought some flowers at the market and immediately took a series of digital photos, just in case I didn't finish the painting that afternoon. As I photographed, I found that I liked framing the subject with the camera and trying a variety of compositions and crops. I rotated the flowers, looking at all sides, and I tested different lighting options: kitchen light, warm studio light, and sunlight.

▲ **Finding My Composition** This is my favorite photo of the series I took. I like the interplay of red and yellow flowers, all surrounded by an abstract, dark green background. I also like how the flowers bleed off the edges of the photo. Remember that if your flowers fit perfectly within the frame, the painting will look static and contrived.

Main Color Concepts

- Make a high-key painting using pure color right from the tube

- Create a center of interest by placing the lightest lights next to the darkest darks

- Use splattered paint to add sparkle

STAGE ONE

Contour Pencil Drawing I try to capture the essential large masses and shapes of the arrangement in my drawing. I don't draw every little petal and leaf; this is not a botanical illustration but rather an explosion of color and expression. I let the flowers connect and merge, even in the drawing. It will be easier to paint the flowers merging if you draw them this way. As I draw, I crop in to the subject and let stems and other elements break out of the edges of the page on all sides.

STAGE TWO

First Washes Using my medium round brush, I begin at the top of the paper with cadmium red. My paper is tilted so the paint will naturally run down. I add permanent yellow-orange, new gamboge, and opera to create a vibrant, multi-colored wash that connects the major flower shapes. I don't worry about defining individual flowers. At the bottom, I add greenish yellow to suggest leaves. The more the colors run together, the better.

STAGE THREE

Stems, Leaves, and Small Flowers I paint the stems and leaves with a mixture of olive green and new gamboge, letting the colors touch and blend in with the flowers. I paint the pink flower petals with opera, using alizarin crimson for the darkest areas and leaving small areas of white paper to separate the petals. I make sure to let some of the elements bleed off the edges of the page; this will help anchor the image and prevent a static and boring composition.

STAGE FOUR

Dark Leaves I emphasize the darkest shadow areas of the leaves with an intense mixture of phthalo blue and burnt sienna, fading it out as it moves away from the bright foreground flowers. I add small cast shadows on the stems under the leaves. To define the centers of the flowers, I apply strokes of a dark mixture of cadmium red and alizarin crimson, switching to olive green and greenish yellow for the yellow flowers.

STAGE FIVE

Background Using a medium round brush, I wet the background and drop in olive green and greenish yellow. I am creating an abstract wash of a variety of colors and splashes. As I move around the painting, I add cerulean blue, cobalt turquoise light, and new gamboge. I create random splashes of color in the background, both into wet paint and over dry areas. In this stage, go for expressive color and whatever moves you.

Details

Background versus Subject Accentuate delineations between the background and subject using complementary colors whenever possible so your painting will vibrate.

White Space Leaving small lines unpainted and white paper visible between colors creates a wonderful sparkle that enlivens your piece.

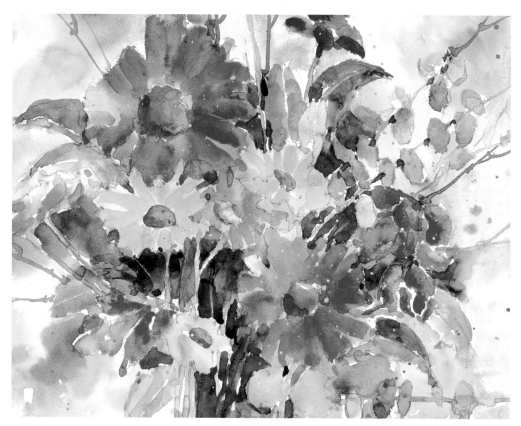

STAGE SIX

Final Details Using a small brush, I indicate shadows on the flowers by painting the side away from the light source a darker shade of the flower color. I use alizarin crimson and cadmium red for the red flowers, switching to new gamboge and permanent yellow-orange for the yellow flowers. Alizarin crimson is a perfect shadow color for the bright pink (opera) flowers. I add a few selective dark greens to clarify the flower petals and punch up the stems. Using a rigger brush, I quickly sweep on some delicate stems that extend off the paper. Finally, I splatter titanium white over the whole painting for a final sparkle.

Bouquet Backgrounds

There are several ways you can approach adding backgrounds to your bouquets, so experiment with the possibilities. Keeping the background free of paint can allow for airy compositions accented with dynamic contrasts (left). A background of softly blended, light washes can effectively set off sharper, richer brushstrokes (right).

CLOSING WORDS

I love all aspects of sketching and painting and doing art, but my favorite part is, of course, color. It stimulates me, excites me, and comforts me. More than anything, it inspires me to create another painting. I finish my drawing, touch a little water to it, scoop up some paint, and let the fun begin.

I encourage you to be bold! It's only some paper and a little paint. Experiment with crazy and unexpected color combinations; add wet paint to a not-yet-dry painting to make blooms; splatter to your heart's content; and break all the rules to see for yourself what works and what doesn't. Most important, discover what works for you. There are still plenty of openings out there for artists with a truly unique vision and a color language all their own.

Above all, have fun!

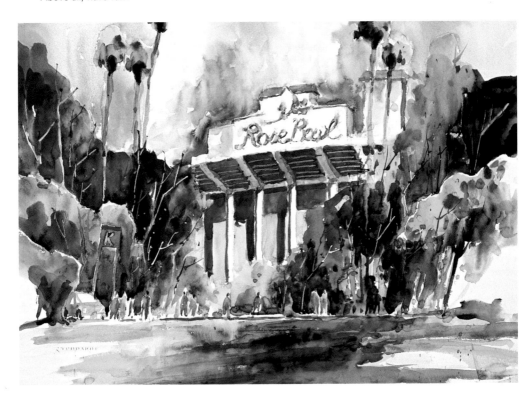